The Still Life
Sketching Bible

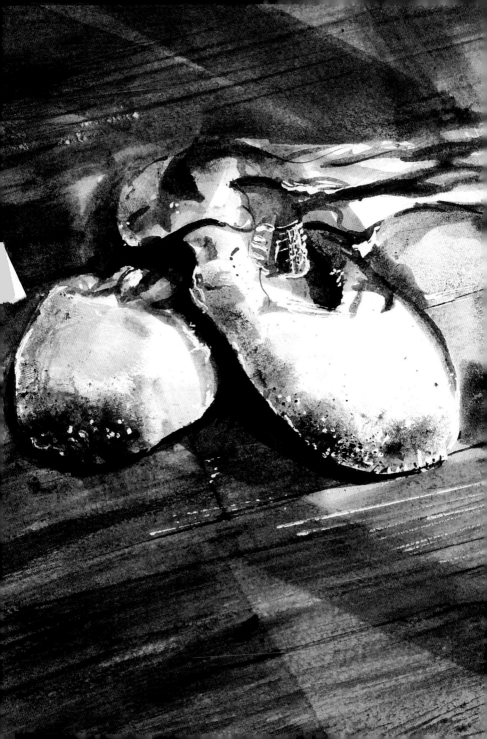

The Still Life Sketching Bible

David Poxon

CHARTWELL
BOOKS, INC.

A QUARTO BOOK

Published in 2008 by Chartwell Books, Inc.
A division of Book Sales, Inc.
114 Northfield Avenue
Edison, New Jersey 08837, USA

Reprinted 2009

ISBN-13: 978-0-7858-2362-9
ISBN-10: 0-7858-2362-X

Conceived, designed, and produced by
Quarto Publishing plc
The Old Brewery
6 Blundell Street
London N7 9BH

QUAR: SLSB

Project editor Emma Poulter
Art editor Tania Field
Copy editor Hazel Harrison
Proofreader Claire Waite Brown
Indexer Dorothy Frame
Photographers Paul Forrester, David Poxon
Managing art editor Anna Plucinska
Art director Caroline Guest

Creative director Moira Clinch
Publisher Paul Carslake

Color separation by Sang Choy International,
Singapore
Printed by Midas Printing International Ltd,
China

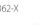

Contents

Foreword

An expanse of clean white paper, a new, sharpened pencil in hand. A momentary excitement, a feeling of expectant anticipation, and then the pencil is lowered and hovers above the surface before finally connecting. Gliding gently at first, pale and wispy marks begin to race with each other and evolve into a glorious trail of granular texture. A twist of the hand makes the marks skip across the paper as a ballerina might pirouette, briefly held in the spotlight. More pressure is applied, then less, and the grip changes from loose to tight, twisting and turning to vary the marks. There is simply nothing like it. Time has no meaning when lost in this process, and all thoughts of worldly matters are abandoned. Filled with hope for the moment, your quest is to capture the joy that you feel in both the drawing process and your subject, and to somehow transfer its essence onto your paper surface.

You are not alone. There are many before you and many more to follow who will make this same thrilling journey. There will certainly be some trials and frustrations, bad days and good, but in the main you will feel uplifted, and there is no excitement to match that of discovering that you have fulfilled your expectations and produced really successful work. I hope that this book, with its carefully planned illustrations and step-by-step demonstrations, will help you set out on the road to becoming an artist, so make time to begin, and take your time to enjoy.

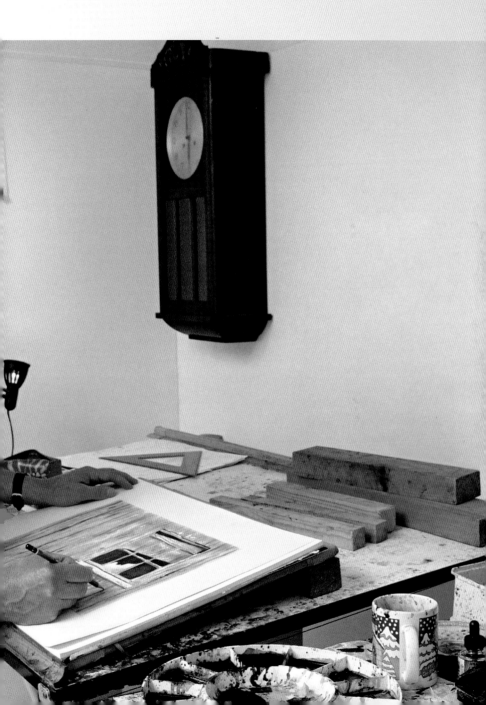

Still life: An historical overview

Since the time of the Ancient Egyptians, art has included what we now know as still life—drawings and paintings of everyday inanimate objects—and the motivation for such picture making went far beyond that of simply recording worldly possessions. Believing that such objects would be of use to the dead in the afterlife, the artists took great pains to render both food and valued treasures as realistically as they could.

In Classical Greek and Roman art, which included lovely decorative mosaics as well as paintings, still-life art moved into a realm where it could be appreciated by a wide audience, both for its aesthetic qualities and as a marker of the power and wealth of its owner.

More than any other branch of art, the still-life genre has been exploited not merely for its own sake as art, but also as a vehicle to express meanings beyond the main theme of the picture. In the Middle Ages and into the Renaissance period, religious and other symbolic meanings were attached to the inclusion of certain objects in paintings, for example, the transience of life was often depicted in the form of flowers, petals, candles, or skulls.

Still-life art evolved into a highly skillful shop window for the brilliance of the Dutch artists of the 17th century. Paintings of tables adorned with the fruits of the earth became extremely popular, and the reputation of these artists spread across Europe, through France and Spain, and further afield.

Of the Spanish artists perhaps the most widely revered is Diego Velázquez (1599–1660) who included wonderful "mini still lifes" of simple kitchenware within his paintings known as "kitchen pieces."

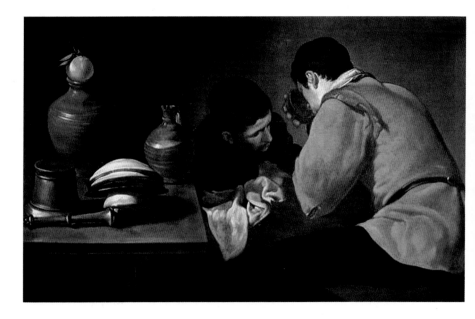

◀ Two Men at Table

Although not technically a still-life piece, this is one of Velázquez's "kitchen pieces" in which exquisitely painted still-life objects feature alongside figures. The painting appears perfectly balanced although seemingly divided into two areas. The translucent fruit placed at the jug's neck is an important compositional feature which helps achieve this visual harmony.

▲ Still Life With Bowls of Fruit and Wine-jar

This piece from the "Casa di Giulia Felice" (House of Julia Felix) dating back to 1st century BC is a typical example of early Roman still life. The Romans made great use of household objects and fruit in their still-life pieces. In the form of paintings and mosaics, their art had a functional, as well as decorative purpose because it often represented the wealth of its owner.

Velázquez was an important influence on the 19th-century French artists Gustave Courbet and Edouard Manet, both of whom painted still lifes as well as many other subjects. Pierre-August Renoir, Paul Cézanne, and Vincent Van Gogh took still-life art into a new dimension where objects were shaped by light and color into designs rich with dancing patterns of textural marks. These paintings were very different to the lavish displays of the Dutch school: Manet often painted the remains of his own lunch—a ham and a loaf of bread—while Cézanne chose fruit and vegetables from his own kitchen and garden. In the 19th to early 20th centuries, the American artist John Frederick Peto created beautiful paintings by combining commonplace objects. Items such as letters, keys, old books, and other trappings of everyday life were interpreted with incredible skill to bring out their subtle textures. Many of Peto's subjects emphasized the precision of the underlying drawing, which ensured that his works were fused with an emotive strength.

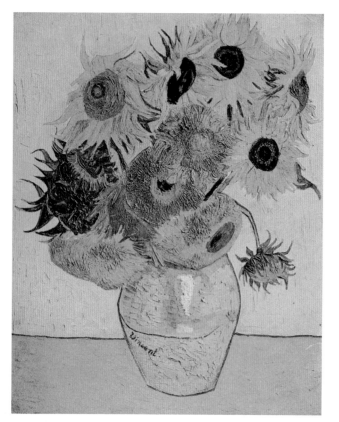

Sunflowers

This is one of a whole series of sunflower paintings that Van Gogh made during the 1880s. The passion he felt toward his art and mark making is clearly visible in the heavy application and swirls of paint.

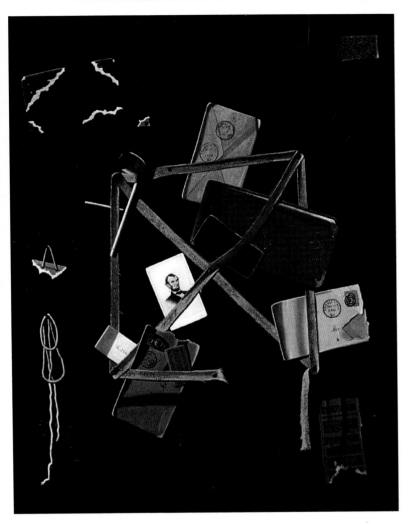

Old-Time Letter Rack

John Frederick Peto, born in 1854, is now regarded as the foremost still-life painter of his period. The above is a piece from the trompe l'oeil genre—a genre of still life that exploits the peculiar nature of human perception to create the illusion of reality of the painted objects. Despite being a master of this genre, Peto was little known in his lifetime. He was completely forgotten after his death in 1907, but was rediscovered in 1947 by a prominent art critic.

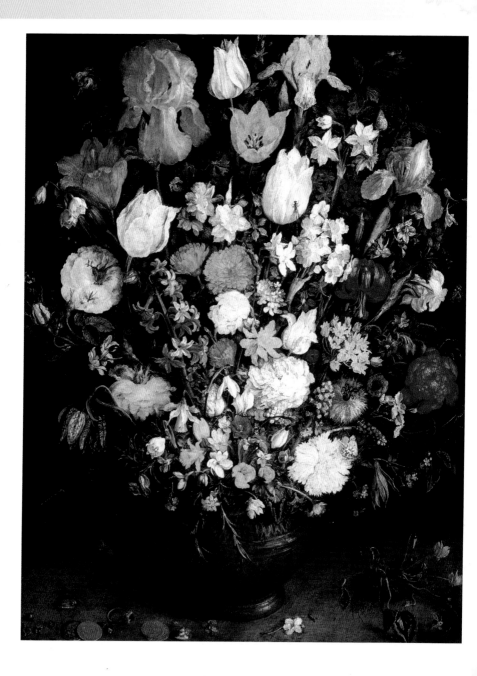

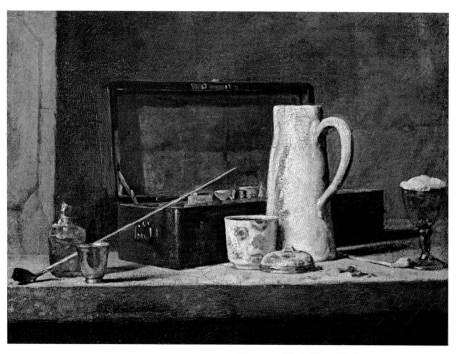

Pipes and Drinking Pitcher
The 18th-century French artist Jean Baptiste
Simeon Chardin transposed the realism of earlier
generations into a more personalized style of
representation. His paintings of simple interiors and
everyday objects, usually rendered in subdued hues
with a limited palette, were underpinned by a
mastery of drawing and composition.

◀ **Small Vase of Flowers**
Jan Brueghel, second son of Pieter
Brueghel, and born in Belgium in
1568, specialized in still life, especially
floral pieces which, like this example
of 1603, took realism to a new level.
He was highly successful, and was
nicknamed "Velvet Brueghel" because
of his consummate skill in rendering
the textures of fabrics.

The will to draw

Drawing could be described as the purest and most honest version of pictorial art. With two simple tools—a pencil and paper—the door is opened to a world of discovery. Art is as old as time itself, and although some may claim that the Neolithic artists made drawings on the walls of caves in order to communicate—to explain their world, to warn of its perils, and to illustrate its bounty—who is to say that their inspiration sprang less from necessity than from an innate need for self-expression?

We see this need to express through pictures in all young children, who by natural inclination have always been fascinated with making marks with anything that can be used for the purpose. Hand-eye co-ordination and learning to manipulate tools is a vital part of human development, and the making of pictures makes an early debut in our lives, quite often even before the power of speech has been developed, and definitely before we have learned to read or write.

The young child strives to make pictures look "real" in the representational sense. Pleasure is derived from the activity of drawing, and from the results, especially when those that view the efforts are able to decipher the marks made as some actual and existing place, face, or object.

▶ *Locked*

Graphite on smooth cartridge paper
Nature and time have had an altering effect upon this old door and its locks, alerting the artist's innate desire to explore through observation and drawing. Enhanced by light and shadow, the overlapping forms reveal a world of texture and beauty that provide an appealing and irresistible temptation for the still-life artist.

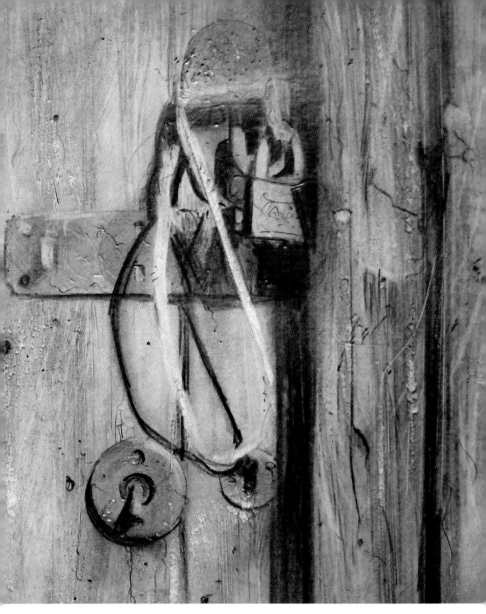

Our inspiration, then, is self-driven, but there is also a need to share our work with others. This "will to draw" takes many forms, and is often the motivational force behind our desire to improve what we produce. What we draw is entirely dependant upon where we are in the world and the circumstances of our existence. Just as the ancients sought to record the world as they knew it, artists throughout history have been moved to use art to make their own statement of their time. The need to reach for paper and pencil is a powerful emotion.

Sometimes it's to improve in our ability to render realism. We do this by practicing and training our eye to manipulate our pencil on the paper, making shapes that our brains might recognize as the world around us. This book and its inclusive techniques and skills will act as a road-map for your development. Along this road you will also be moved to use these skills to draw for more ephemeral reasons—just as a musician composes a song, or a dancer moves his or her feet in rhythmic harmony.

To want to draw is an integral part of the human psyche, as is the desire to improve—to want to improve is an inevitable consequence to be celebrated each time inspiration strikes.

▼ *Car*
Drawn in pencil and ink
A still-life statement of our time, this rusting car makes for a powerful composition. Skills can be honed while enjoying the sheer pleasure of drawing and making art.

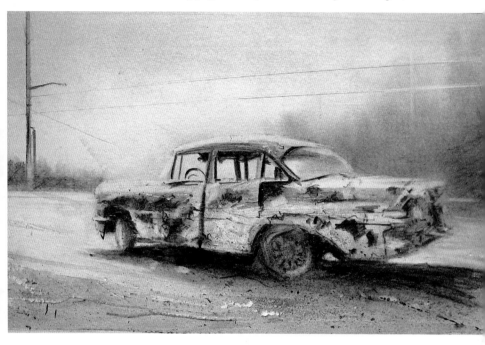

◀ *All He Left*
Pencil preparatory study
We are influenced by where we are and what we feel inspired to record. This abandoned work station in an old clay pipe factory made a poignant statement on the fleeting nature of life and the values placed on material possessions. The still-life artist in particular is sensitive to the soul imbued by such subject material.

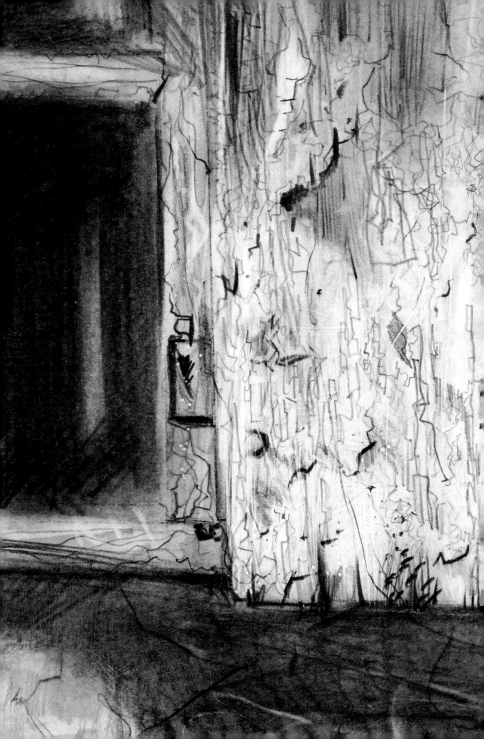

Chapter 1

Equipment

Getting started

Art supply outlets are very tempting places, often giving you the idea that acquiring a new piece of equipment will suddenly propel you into the creative stratosphere. It is best to go prepared with a shopping list and buy only what you absolutely need—you can always add on later as you work your way through the skill levels. The following is a suggested list of inexpensive tools and equipment that will get you started.

Grades 4B, 2B, and B pencils

Pure graphite sticks

Kneadable eraser

Plastic eraser

Compressed charcoal sticks

Pencil sharpeners

Sketchbooks

ABSOLUTE BASICS

PENCILS: Grades B, 2B, and 4B.

PAPER: A sketch pad at least A4 size (A3 if you can stretch to it) consisting of smooth drawing paper.

PRACTICE PAPER: A block of cheap, disposable copy paper.

PENCIL SHARPENER: It is vital to keep a reasonably sharp point.

ERASER: Plastic eraser, everyone makes mistakes.

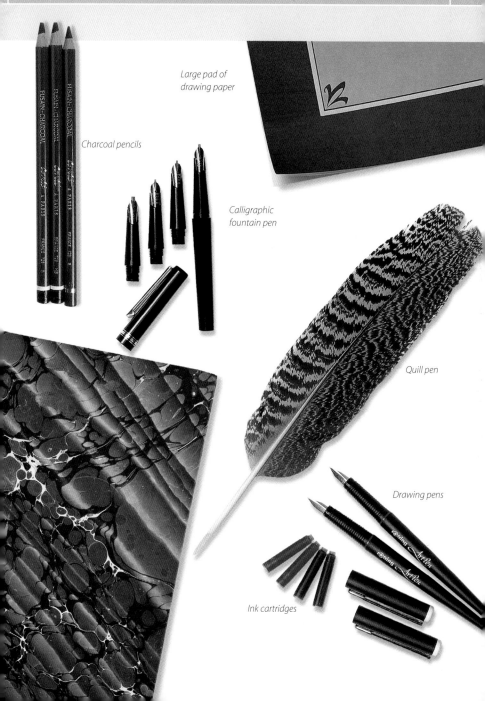

Large pad of
drawing paper

Charcoal pencils

Calligraphic
fountain pen

Quill pen

Drawing pens

Ink cartridges

Pencils

Graphite pencils as we know them today did not come into use until the 18th century, and were originally called "blackleads" after the lead point, or silverpoint, pencils that had been used in the 16th century. They are still often called lead pencils, but in fact the material used is graphite, which is a non-toxic mineral.

Today the common wood-cased pencil contains a graphite and clay core of varying hardness. Manufacturers differentiate the hardness of their pencil range by the use of letters and numbers. H (followed by a number) generally denotes a hard core, the higher the number the harder the core, while the B range signifies the blackness or softer qualities of the core. Most manufacturers produce a range from 2B to 9B and from H to 6H. The mid-point in the range is denoted by HB, which stands for hard and black. A pencil marked with the letter F signifies that it can be sharpened to a fine point.

Clutch pencils

These are also known as mechanical pencils. Although more expensive than their wooden relatives, their main advantage is consistency of weight.

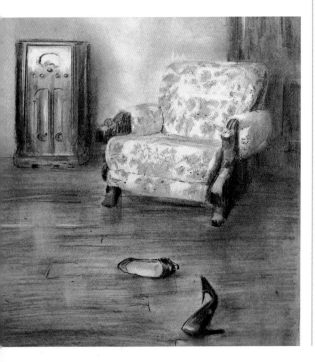

Radio Days
Graphite on smooth cartridge paper.
Here the artist has successfully captured the relaxing interplay between the the comfy chair, shoes, and old radio, illuminated by the soft interior lighting.

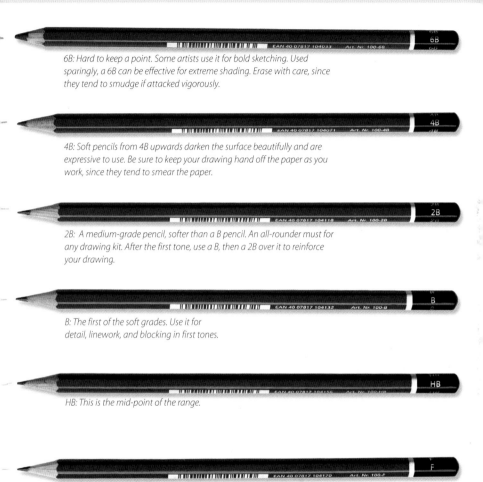

6B: Hard to keep a point. Some artists use it for bold sketching. Used sparingly, a 6B can be effective for extreme shading. Erase with care, since they tend to smudge if attacked vigorously.

4B: Soft pencils from 4B upwards darken the surface beautifully and are expressive to use. Be sure to keep your drawing hand off the paper as you work, since they tend to smear the paper.

2B: A medium-grade pencil, softer than a B pencil. An all-rounder must for any drawing kit. After the first tone, use a B, then a 2B over it to reinforce your drawing.

B: The first of the soft grades. Use it for detail, linework, and blocking in first tones.

HB: This is the mid-point of the range.

F: Indicates the pencil can be sharpened to a fine point.

H: Indicates the hardest range. Use H pencils for pale silver tones and lines. Their fine point is useful for precision drawing.

Charcoal

Charcoal, which has been used for drawing since art began, is simply charred wood, usually either vine or willow, the latter being lighter and more fragile. It is sold in a variety of sizes, none of which are absolutely constant due to the nature of the material. Its naturally crumbly texture makes it a messier medium to use than the pencil, but it's excellent for making unfussy tonal sketches and for building up areas of tone very quickly.

Charcoal is also made in pencil form. Much like an ordinary graphite pencil, this uses compressed charcoal in an enclosed wooden casing, and is therefore slightly harder. It is easier to manage and control than stick charcoal, and has the advantage of keeping your hands relatively clean. It comes in three grades only: light, medium, and dark, providing an opportunity for a real "workout" of mark-making techniques.

ARTIST'S TIP
To erase charcoal, use a kneadable eraser, which lifts it off cleanly—a plastic eraser will just smudge it. You can also reclaim lights with this type of eraser, and even use it for certain blending applications. Try using charcoal on toned paper too, as this enables you to work up to the lights and down to the darks.

Charcoal forms
As shown above, charcoal comes in many forms, enabling you to produce drawings that contain a great variation in line quality.

Mark-making with charcoal

Charcoal is an expressive medium that responds well to fluid drawing movements and variations in pressure, making it easy to create a number of different marks.

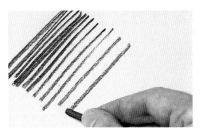

Thin charcoal can be used to produce expressive, linear strokes.

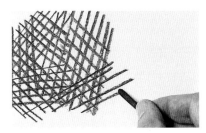

A web of crosshatched lines can be used to build areas of tone or texture.

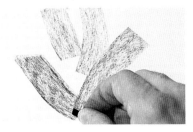

Use the side of a charcoal stick to create thick marks and to build up tone quickly.

Using the sketch grip (see page 56) and applying the side of the charcoal to the paper, you can build up layers of tone in a reasonably precise and controlled manner.

TIPS FOR APPLICATION

Charcoal pencils can be used in the same way as graphite pencils, utilizing all the same techniques, including the blending methods (see pages 60–61), but here are some extra tips:

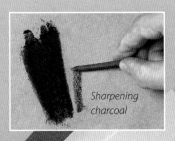

Sharpening charcoal

■ You may find that a textured or rough paper is best when using the natural charcoal, and a smooth paper for the pencil version. For extreme lights, either leave as white paper, or use a piece of chalk or white pastel pencil.

■ Sharpening can sometimes be a frustrating experience because the charcoal tends to break easily under pressure. Using a piece of glasspaper to manipulate the charcoal to a point will help.

Ink

There are many types of drawing ink, the three main groups being shellac-based waterproof inks, which cannot be mixed with water; non-waterproof inks, which even when dry can be softened and spread by washing over with water; and liquid acrylic inks, which are completely waterproof when dry but can be mixed with water and used to lay light- or medium-toned washes. These, like some other inks, are made in a range of colors, some of which are transparent and others opaque. However, for the drawing examples in this book, only monochrome inks are used, either sepia or black.

①
②
③
④
⑤
⑥
⑦
⑧

From left to right:
Steel nibs (1 & 2), fine paint brush (3), dip pens (4 & 5), technical fine-line pen (6), biro (7), brush pen (8) and marker pen (9).

ARTIST'S TIP

Use smooth paper for best results when working with ink and pen. Always have clean water available, and rinse your pen or brush in between applications. Have a roll of kitchen paper and blotting paper to hand for cleaning up.

Drawing with ink

In the Western world the implement most associated with ink is the pen. Pens were originally made from large feathers (quill pens), and these were followed by metal nibs that fit into a wooden holder. Both of these are still used by artists, but there are also many other types of drawing pen available. In the East, especially in China, drawing with brush and ink produced matchless works of art, and Rembrandt also exploited brush and ink to make a number of highly expressive drawings.

An incredible variety of marks can be made with ink: some are "considered" and carefully placed, while others can be applied loosely, almost carelessly, in what is known as a "gestural" manner. The type of implement used to make the mark obviously influences its appearance, so it is worth experimenting, not just with your art-store drawing tools, but also with other objects—objects such as sticks or even cloths can be used to apply your ink.

Quill pens
Introduced at around 700 AD, the hand-cut quill pen is still a superior calligraphy and drawing tool, providing a sharp stroke and flexibility unmatched in steel pens. The shaft of the feather acts as an ink reservoir and ink flows to the tip by capillary action.

MAKING A QUILL
Quill pens are made from large primary flight feathers taken from the wings of birds such as swans, geese, and turkeys. Quill pens are now a thing of the past, but why not try to make your own? They are relatively easy to make— providing you can find a suitable feather— but the quill will wear with use, and as a result will require periodic recutting.

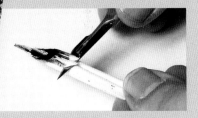

1 To shape a quill, first cut the underside of the feather at an angle.

2 Shape both sides of the quill equally.

3 Allow the ink to flow out by splitting the end. Your quill pen is now ready to use.

Mark-making with ink

Ink is a versatile medium which can be used to make a variety of marks. Here are some examples of the range of marks that can be made with an array of different implements.

Drawing with a stick
Here a small broken stick was used to make the marks. Some artists use a piece of bamboo, sharpened at one end, to achieve similar effects. The stick holds a surprising amount of ink, and a range of interesting marks can be achieved. Some are textural and gestural, but the tool can also achieve considerable precision and detail.

❶ Hatching
Here a dip pen and black ink has been used to apply various hatching strokes. Dip pens can accept a wide variety of nibs, making them very versatile.

❷ Crosshatching
Hatching and crosshatching are the traditional methods of building up areas of tone in pen and ink drawings. Lines can be precise, or loose and random.

❸ Curved hatching
This form of hatching with pen and ink follows the shape of the object, suggesting not only the form but also the direction of light.

❹ Dotting
Random dots, sometimes known as stippling, can be used to add texture effects or detail to any subject. Utilizing the writing grip (see page 56), a dip pen and ink were used to "dot" the surface quickly with the point. Old walls, peeling paint, antique furniture, or well-worn fabrics are just a few examples where this technique might be applied.

Brush marks
Marks made with a brush and ink can be very varied, as shown in these examples.

❺ Pressing the whole of the brush onto the paper.

❻ Dotting with a brush.

❼ Making long, curved lines.

❽ Crosshatching with a brush.

❾ "Starving" the brush. At the end of a stroke the brush runs out of ink and becomes drier, and you can use this dry-brush method to create texture marks. This is particularly good for rendering any rough textures. Apply the brush to the surface sideways, holding it loosely in a sketch grip (see page 56), and lightly skim across the paper.

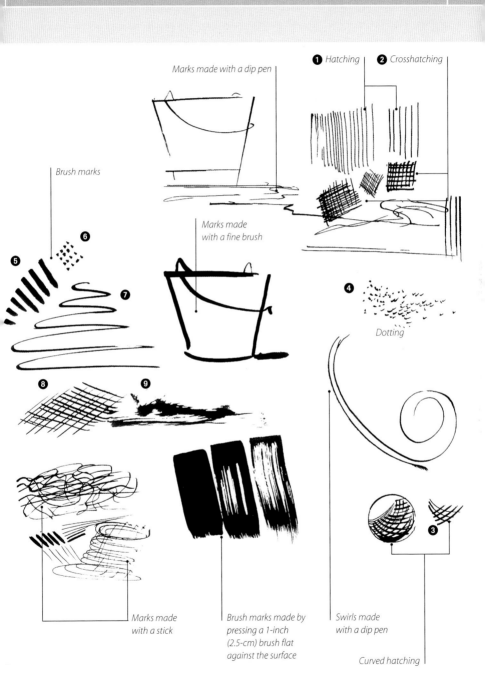

Marks made with a dip pen

❶ Hatching ❷ Crosshatching

Brush marks

Marks made
with a fine brush

❹

Dotting

❺

❻

❼

❽

❾

Marks made
with a stick

Brush marks made by
pressing a 1-inch
(2.5-cm) brush flat
against the surface

Swirls made
with a dip pen

❸

Curved hatching

Drawing surfaces

There are numerous types of drawing paper, from individual sheets to pads in varying sizes, weights, and surfaces—from smooth to textured. Paper is made in different weights, expressed as lbs per ream of paper (500 sheets), and the heavier the weight, the better the paper will stand continual reworking.

The surface you use is really a personal choice, depending on the kind of drawings you intend to do and the medium you will use, and it is worth experimenting to find the one that works best for you. It's possible to spend a small fortune on paper, but avoid doing this at the start, as you find your way through your art experience. A cheap pad of copy paper is useful for experimenting or working out compositional or other picture-making issues. Once confident in both your subject and your ability to render the key elements, you can begin working on your quality drawing paper with less fear of wasting expensive materials.

PAPER SIZES

Paper is usually sold in A sizes, which are internationally recognized. A1 is the largest size and A5 the smallest you will need. Each size, from A1 down, is half the previous one. You may find the following conversion into imperial and metric measurements useful.

A1: 33 x 23$^3/_8$ in (840 x 594 mm)

A2: 23$^3/_8$ x 16$^1/_2$ in (594 x 420 mm)

A3: 16$^1/_2$ x 11$^3/_4$ in (420 x 297 mm)

A4: 11$^3/_4$ x 8$^1/_4$ in (297 x 210 mm)

Paper types

There is a wide variety of papers available and although in most cases smooth drawing (cartridge) paper will be your chosen surface, you may need to experiment to find what works best for you. Different papers suit different drawing media, for example a pen will draw best on smooth paper while charcoal needs a rougher surface—what is often described as a paper with some "tooth." Cartridge paper is a good all-rounder. Smooth watercolor paper is excellent for ink, or if using wash, whereas charcoal (Ingres) paper and textured watercolor paper give an interesting texture to charcoal drawings.

Handmade, textured watercolor paper

Textured cold-pressed paper

Medium cold-pressed paper

Rough cold-pressed paper

Smooth, hot-pressed (cartridge) paper

Smooth watercolor paper

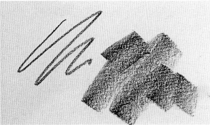

Point and side strokes with graphite stick on smooth drawing paper.

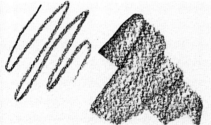

Point and side strokes with graphite stick on textured watercolor paper.

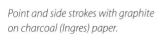

Point and side strokes with graphite on charcoal (Ingres) paper.

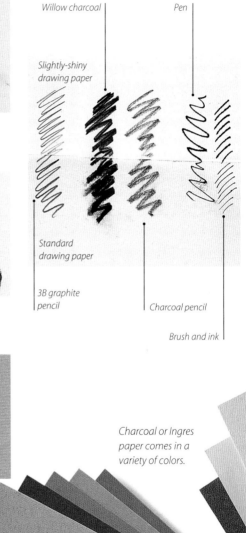

Willow charcoal

Pen

Slightly-shiny drawing paper

Standard drawing paper

3B graphite pencil

Charcoal pencil

Brush and ink

Charcoal or Ingres paper comes in a variety of colors.

Stretching paper

When working with dry media, or in a sketchbook, there is no need to stretch your paper prior to drawing. However, if you decide to implement ink, or a wash, then stretching paper is a necessary measure. When wetted, paper fibers absorb moisture and swell, causing the paper to buckle. When the fibers dry they shrink again, but not always to their original size. This is when buckling occurs. The application of arcylic inks over such an uneven surface, can be difficult. Stretching the paper helps to solve this problem by ensuriing the sheet dries flat. You will need a sheet of paper, a wooden board (larger than the paper itself), adhesive-paper tape, a sponge, a craft knife, and clean water.

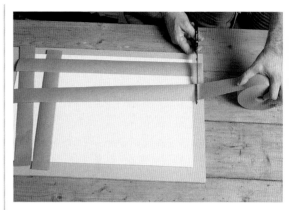

1 Prepare four strips of adhesive-paper tape, cutting each strip approximately 2 inches (50 mm) larger than the paper.

2 Lay the sheet of paper centrally on the wooden board and wet it thoroughly by squeezing water from the sponge. Alternatively, the paper can be wetted by holding it under a running faucet, or by dipping it into a water-filled tray or sink.

3 Wipe away any excess water with the sponge, taking care not to distress the paper surface.

4 Beginning on the longest side of the paper, wet a length of tape using the sponge and lay it down along one edge. Ensure that about one-third of the tape surface is covering the paper, with the rest on the board.

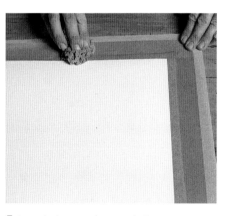

ARTIST'S TIP

Staples can be used to secure medium- and heavyweight papers. Wet the tape and position it on the board, as below. Secure the edges by placing staples about 1/2 inch (13 mm) in from each edge and at 1/2–1 inch (13–25 mm) intervals. Work quickly, before the paper buckles, and allow to dry.

5 Smooth the tape down with the sponge. Apply tape in the same way along the opposite edge and then along the other two edges. Place the board and paper aside to dry for a few hours; or use a hair-dryer to speed up the process, but keep the dryer moving so that the paper dries evenly, and do not hold it too close to the paper's surface.

Blending tools

The best way to create realistic three-dimensional forms is by blending (see pages 60–63). Forms can be built up through various types of line work, but this is a slow process, whereas manipulating the drawing material on the paper surface to produce smooth blocks of shading is much quicker and more effective. There are a number of tools you can use for blending, some of which can be improvised. For example, tissue paper, although not necessarily a first choice for blending, can be useful for charcoal or ink blending, which are messy jobs, and its disposability means it is a good, cheaper alternative to using a rag.

Finger

Many artists use their fingers to blend. The disadvantages are that your fingers get dirty, and more importantly, residues of moisture can make your working surface greasy.

Rag

Any piece of discarded fabric can be wrapped around your finger to produce controlled blends. Similarly, a thicker chamois leather can be used, and although more expensive, will help to grip and work over larger areas.

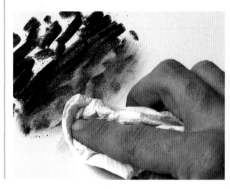

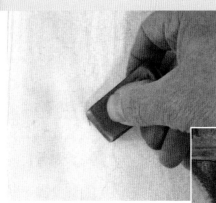

Eraser blending

An eraser can also be used as a blending tool. Here the pencil surface is being stroked with a plastic eraser. Take care not to apply too much pressure, otherwise your marks will disappear.

This eraser-blended graphite has a slight sheen, which can be effective in some cases.

Paper stump (torchon)

This traditional blending implement, a compressed cardboard stump, is available from art stores in various sizes, or you could try making your own as shown on the right. Use a paper stump (torchon) for accurate, controlled blending where precision is key. Apply the torchon in the direction you want the blend to go. When the end becomes blunt from use, you can either peel away layers of card, or even sharpen with a sharpener.

HOW TO MAKE A TORCHON

To make a torchon, you need a toothpick and a small piece of paper towel. Soak the towel in water and then roll it around the stick, without letting the paper protrude too far beyond the points of the stick. The paper will shrink as it dries to form a tight covering, without the need for further adhesion.

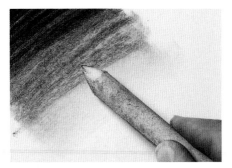

Erasers

Mistakes happen even to experienced artists, so make sure you have an eraser to hand. This is an important piece of equipment, because it can be used not only to remove errors, but also to re-establish or emphasize highlights in the later stages of your drawing. It is also an effective blending tool (see pages 34–35).

There are basically two types of eraser, the plastic type and the "putty" type. The latter is made out of a kneadable soft material and can be formed into a point for precise work such as reclaiming small highlights. Both types get dirty quite quickly, so care is needed before applying to your surface, since muddy eraser marks can spoil your artwork. The plastic erasers can usually be cleaned by rubbing over a clean piece of paper, and if this doesn't work, the plastic can be "filed" down using an abrasive surface—rough card is adequate for this. Alternatively, a new edge can be made by cutting off a piece of the plastic with a craft knife. The kneadable eraser can be folded back on itself, thereby hiding the contaminated surfaces.

Another useful eraser is the small cylindrical type that fits into the ends of pencils. These are invaluable for lifting out small highlights.

Putty or kneadable eraser

Plastic eraser

Erasing effects

Erasers are an extremely versatile tool and can be used to work a range of media and create a number of different effects. Charcoal is particularly receptive to being worked into with various erasers, enabling you to produce a variety of effects—from fine, crisp, sharp lines to texture and highlights.

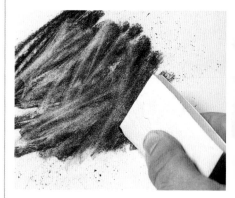

SEE ALSO

Blending tools, pages 34–35
Aids to accurate drawing, pages 38–43

Lines

Hard vinyl erasers can be used to create thin, sharp lines. Erasing alongside a ruler will help you retrieve hard and straight white lines. Similarly, you can obtain clean, steady lines by erasing around curved objects such as buttons, washers, or the flexi-curve (see page 39).

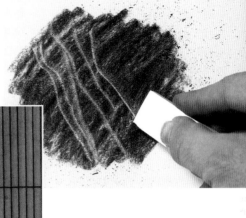

ARTIST'S TIP

One word of caution when using a kneadable eraser. If you intend to use a paper stump (torchon) as your blender after erasing, you may find that the eraser has left a faint surface grease that prevents the blending tool from working well. It can also scuff the paper surface or leave you with an unwanted mark that is very difficult to remove.

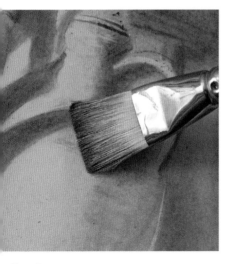

Cleaning

An old but clean paintbrush is useful for gently brushing off left-over eraser material from your work without disturbing your drawing. You should try to avoid touching the surface with your hands or fingers except where absolutely necessary.

Aids to accurate drawing

Some artists prefer to draw all lines freehand, while others are not above getting a little help, especially when absolute accuracy is necessary and time is tight. A ruler is an important piece of equipment for two reasons. First, in still-life work you do need some edges to be really straight and not wavy, so don't be ashamed of using the ruler to draw these in. You can also use it to plot your search and perspective lines when working out your composition.

Second, the ruler can be used to measure objects in the subject. Sometimes the eye tricks us and we are not sure how large things are in relation to other elements in a scene. For example, is an object wider than its height, and how does it compare in size to another object? Use your ruler to get quick answers so that you can concentrate on the important part of your art making. Additionally, you might want to draw an object life size, so if it will fit on your paper you can measure it and plan the shapes with total precision.

The ruler

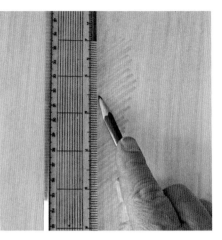

Ruled lines
Draw precise straight lines with a ruler.

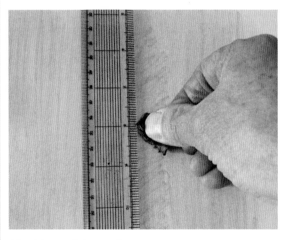

Masking with a ruler
Your ruler can also be used as a straight-edged mask. Here it is positioned in order to use the rag-blending technique in an absolutely straight line.

The flexi-curve

Made from a flexible rubber material, this is a useful addition to your drawing kit. Curves are notoriously hard to draw accurately, but the flexi-curve can be bent to match any curved or round object. You can then place it on your drawing surface and simply use the bent edge to guide your pencil. It's particularly handy for rendering the ellipses on bowls or other circular objects that are at an angle to you.

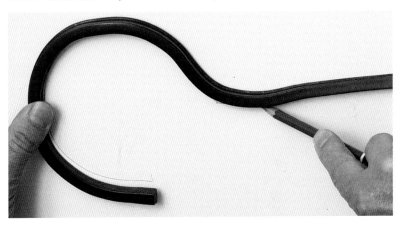

Using the flexi-curve

Having bent the flexi-curve to match the object, position it on your paper and draw along the edge.

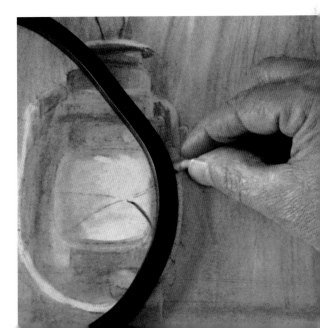

Erasing with the flexi-curve

In this example, the flexi-curve is being used in order to erase a curved edge with a small plastic eraser.

The viewfinder

Deciding where your picture will start and end, how much to put in or leave out, and whether you want to take a close or distant view can be quite problematic. You may sometimes find that once the elements are drawn on the paper your earlier compositional choices just don't look right. The viewfinder can come to your aid by helping you to frame the subject in different ways before you commit work to paper. A viewfinder is easily made by cutting a rectangular aperture in a piece of card. Hold it up at different angles and different distances from your eye until you have found your perfect framing for your subject. Remember where the "edges" of your composition are and mark them onto your working surface.

Some commercially made viewfinders have divisions drawn onto a see-through plastic covering. These divisions are sometimes useful for composing and designing your picture.

A viewfinder will present you with many more compositional choices.

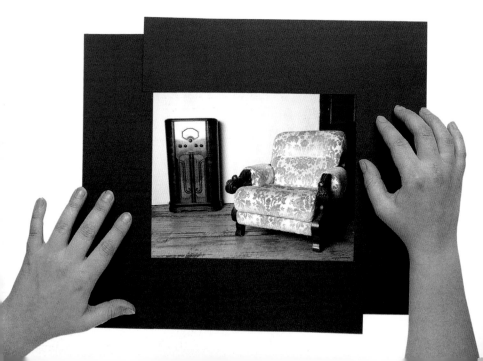

The plumbline

It's very important to establish a true vertical line at the drafting stage of your artwork, and a plumbline, such as builders use, is a great help here. Taking a few moments at the beginning of your drawing session will pay dividends later, and avoid the necessity of making major corrections. By starting with one true line you will be able to establish all other lines and angles relative to your first vertical.

It's very easy to make your own plumbline with a piece of string (no longer than 6 inches/15 cm) and a small weight such as an old bolt or some other item from a toolkit. Simply tie the weight to the end of the string.

How to use a plumbline

Hold your plumbline at arm's length and look carefully to establish which are the true verticals in the scene before you. Transpose these to your paper surface, at right angles to the top and bottom edges. This will give you a firm foundation from which to gauge all the other angles in your drawing.

This preparatory pencil and ink study for a later painting was positioned on the surface with the aid of the plumbline. With subjects that require a lot of subsequent detail work it's vital to get the first marks down accurately.

The angle finder

When you first look at your subject, try to decipher it into a simple "code" of lines and angles. This will help you analyze what is important to make the picture work. To help you find the angles correctly, rather than guessing what they are and where to put them on your paper, use an angle finder. Like the plumbline, this can be made in five minutes. All you need is two rectangular pieces of card 6 x 1 inches (15 x 2.5 cm), which you then clip or tie together at one end so that they can be rotated against each other. With practice you will be able to measure all the angles in your subject so that you can render them accurately onto your drawing surface.

Identifying the angles

The angle finder is a simple but invaluable guide, and with practice will help you to plot the most difficult forms. This spiral staircase is a complex, double-helix design. Tackle complicated subjects like this one line and angle at a time—start with a true vertical, and then move across the object, linking angles with intersecting landmark lines as you go.

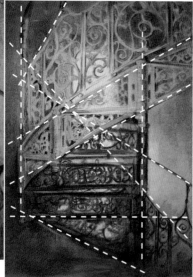

Assessing and transferring angles

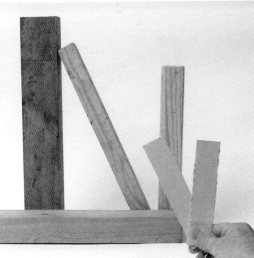

1 Once you have found your first true vertical with the plumbline, hold the angle finder at arm's length to relocate it, then rotate the other piece of card until it coincides with whichever angle you are trying to identify.

2 Having established the angle, move the angle finder onto your paper surface, taking care to grip it firmly so that you don't lose the angle. Place the vertical card on your established vertical line and simply draw along the card. Then move on to your next angle, using your first placement to guide you. You can repeat this process as many times as you like during your drafting session, and make minor adjustments accordingly.

ARTIST'S TIP

Always measure your angles from exactly the same standing position, as any change in your own position will dramatically affect the whole perspective of the subject. It is thus important to recheck some of your earlier angles as you progress through your artwork.

Easels and drawing boards

At the drafting stage precise drawing is vital, and you will find that it helps a great deal to have your paper supported in an almost vertical position. This will enable you to transpose any vertical lines and angles more accurately, using the tools described earlier (see pages 38–43). It is easier to resolve any perspective issues if your paper is held in the same plane as your subject. Once your preparatory drawing is accurately in place, you can put your work on a less inclined plane if this is more comfortable for working.

There are many different kinds of easel available, made in either wood or metal. Shape, size, and cost are always factors to take into consideration, as is weight—if your easel is to remain in the studio you could use a heavier, less portable one than you would want when working on location.

The all-in-one easel
This easel comes complete with a storage tray and sliding lid. The box hooks onto the easel and can be detached and carried separately, which makes it ideal for outdoor work as well as in the studio.

BUYING AN EASEL: POINTS TO CONSIDER

- How easy is it to erect your easel?
- Can it be erected and disassembled quickly?
- Where will you store your easel?
- Do you need to transport it?
- How big is the art you intend to produce?
- Do you want your easel to adjust into a near horizontal format?
- Will your easel take the weight of a wooden drawing board?
- Do you wish to work standing up or sitting down?

Drawing boards

A firm support for your drawing paper is essential. Size will obviously be determined by how large you wish to work, but you might have two or three sizes for different types of work. Drawing boards can be purchased in art stores, but it is much less expensive to make your own from wood or composition board sold for furniture, shelving, and so on. However, make sure the board has a smooth surface, since any texture, such as that of plywood, will come through in the drawing. MDF (medium-density fiberboard) is a good choice, and is not prone to warping. It should be no less than about 1/2-inch (1 1/4 cm) thick, though you might use a lighter one for outdoor work. You can fix your drawing paper to the board using either clips or masking tape.

An angled board is ideal for drawing.

Working position

You may be used to working on a flat surface, but a sloped surface will improve your posture. Adjust your board so your back is straight

ARTIST'S TIP

If your choice is a wooden easel, make sure it is constructed from hardwood and that its fittings are in brass or steel. Soft-wood easels may warp, and aluminum fixings can easily be damaged.

Sharpening

The importance of keeping your pencil sharp cannot be over-stressed, as without a well-sharpened pencil your work will be "blunt" in more ways than one —there is no way to get precise marks other than with a really sharp tip to your graphite. Additionally, a lot of your drawing, particularly shading using the sketch grip (see page 56), will require an exposed edge of graphite, and if your pencil is blunt you will be severely restricted in the types of marks or techniques you can use.

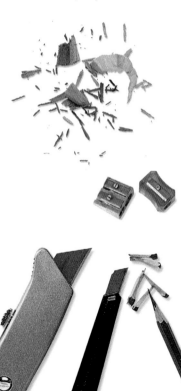

Using the point

Fine detail can only be rendered with a really pointed pencil tip, however, care must be taken not to exert too much pressure as this will break the point. The relative fragility of the graphite varies between manufacturers and the varying grades of pencil.

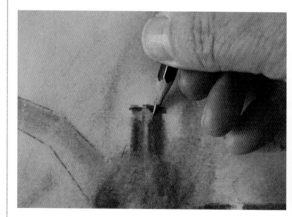

Try not to cover up the small area of paper on which you intend to make your marks, because you need to see where you are placing your lines. Here, a sharp-pointed B pencil is being used to render exact detail on this bottle.

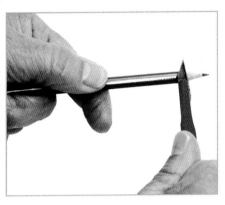

Sharpening with a knife

There are several ways to sharpen your pencils, the traditional one being to use a blade such as that found in a craft knife.

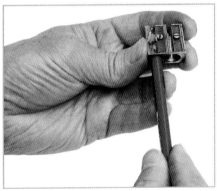

Using a pencil sharpener

Pencil sharpeners are useful devices, and are made in several shapes and sizes, including double-barrelled versions (as shown here on the left). Just put the pencil in the hole and apply some pressure as you turn the shaft, taking care not to break the point.

Abrasive paper

A piece of glasspaper is extremely useful, especially for sharpening charcoal pencils. It can also be used for tightening up the points of graphite pencils, so keep a sheet handy.

Finishing touches

After you have completed your work you will need to spray it with fixative to protect it. The drawing mediums discussed in this book are quite fragile, and can easily become smudged or blurred if other drawings or paper are placed on top. There are a number of proprietary fixing solutions that you can purchase from your art supply outlet, but regardless of which type you choose, it's very important that you follow the manufacturer's instructions as to safe usage.

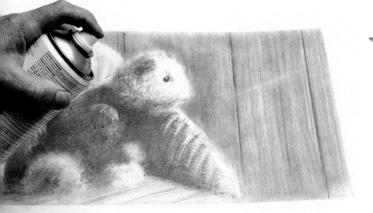

Non-aerosol fixatives are another alternative.

Fixative spray

Hold the spray can about 12 inches (30 cm) from your picture and spray evenly across the surface. Make sure the room is well ventilated. There should be little or no visible change after spraying your work with fixative solution. Always spray in a flat position, and leave your work flat to dry off.

MAKE YOUR OWN

Fixatives can be toxic or inflammable. To avoid these health and safety issues, try making your own, ozone-friendly solution. For a clear, non-staining, permanent fixative, dissolve half a teaspoon of gelatin powder in two pints of hot water. Leave this until it is lukewarm, then apply it immediately to the drawing with a brush or spray. If the mixture is allowed to cool it will begin to set.

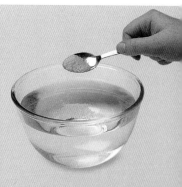

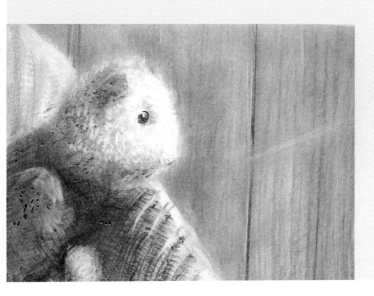

Mounting your work adds the finishing touch to your drawing.

Mounting your work

Having patiently and carefully produced your drawing, assessed it, and been satisfied with the results, you will naturally want to present it to the world in a professional way. But before committing your work to a framer, have a look at how it will look with a mount around it. You might buy a few ready-made mounts from your art supplier in a variety of different proportions and sizes—potrait and landscape, or even square. By experimenting with your studio mounts first you will be able to see if your work needs to be cropped, or if it is ready to go to the framer as it is.

Normally a plain ivory colored mount will compliment all the drawing mediums in this book. Your mount should support your artwork, not compete with it. Be generous with the size of the mount border—you will find that a border at least 3 inches (7.5 cm) wide enhances your drawings.

ARTIST'S TIP
When mounting, consider the size of the mount carefully. The bigger the mount, the more important your drawing will appear.

The workspace

In a perfect world every aspiring artist would have a dedicated area where equipment could be left set-up, because it's important to be able to get started quickly when inspiration strikes. However, this is not always possible, and you may have to make do with a temporary workspace and put your equipment away after each session—it is perfectly possible to produce good drawings in a corner of a kitchen or living room. Here are a few things to bear in mind when deciding on a suitable space.

■ Try to position your working area where you will receive north light. This is the most consistent light source, whereas bright sunlight on your paper makes it difficult to judge the tonal structure of your drawing.
■ You may want to experiment with artificial light and shadow shapes in your still-life set-ups, in which case you can still work in daylight, but shield your subject from direct daylight with a makeshift screen.
■ You may find that sitting to work is more comfortable than standing. This is a personal choice, and good back support is vital. Try not to slump over your working surface.
■ A sturdy table is vital, and a few pieces of wood are useful for propping your board up at an angle.
■ Keep your equipment on a tray, so that if your improvised studio is suddenly required for some other activity you can quickly remove everything without packing it away. Likewise, your still-life arrangement can be set up on a board, or a trolley on wheels, and the whole thing removed and repositioned as required.

The author's studio

Being able to have your own studio is a luxury. Here, the working area is set up adjacent to the large north-facing window. Several sturdy surfaces support the drawing board and equipment, which is all within arm's reach.

Shelves close by fc those everyday instruments.

A large window giving bright natural light from the north.

All drawing and painting materials should be close at hand.

A sturdy table and/or drawing board for support.

Blocks of wood for tilting your drawing board at different angles.

A wall close by can display those works-in-progress, or inspiration.

ARTIST'S TIP

As a still-life artist you may need storage space for props in addition to your drawing equipment. Without a studio you will have to keep them wherever you can, but if you do have a dedicated space, a range of sturdy shelving and hooks is ideal. Having your object collection always on display means you will never be without a potential subject.

The outdoor kit

Portability and comfort should be your main consideration when going on location to make art. You need very few pieces of equipment to go on drawing trips, and the less you carry the more easily you can roam around to find the ideal subject. At its most basic, all you really need to make a drawing is pencil and paper. If you have transport that can take you close to a subject, equipment is less of a problem. A portable easel that you can assemble quickly, a comfortable outdoor chair or stool, and an umbrella in case of inclement weather—or too much sunshine—are all useful items you may consider taking with you. Your drawing equipment needs to be protected, so use a toolbox or wrap, and a waterproof portfolio case for your paper. And don't forget your liquid refreshment—art making is thirsty work.

Be at the ready, always carry a sketchbook and pencils with you wherever you go.

The traveling kit

Using a canvas wrap is a good way of storing your drawing kit. It holds a surprising amount of equipment. Toolboxes are another excellent storage device for the artist, and don't cost a fortune. Your paper should be stored flat, and there are a variety of portfolio cases available to suit all pockets.

A canvas wrap is useful for storing and transporting your drawing implements.

A waterproof portfolio will protect your paper and work while in transport.

Collecting information

Try not to be inhibited when on sketching trips, and, if possible go with a group of other artists, since this is enjoyable and helps you to sharpen your techniques and train your eye. A camera is a useful aid for collecting information, particularly detail, when time is limited. It should be used as an additional resource for gathering information and not relied upon entirely. Remember that the camera records reality, the artist interprets it.

Use a camera to capture your subject, before retreating to your studio to draw it.

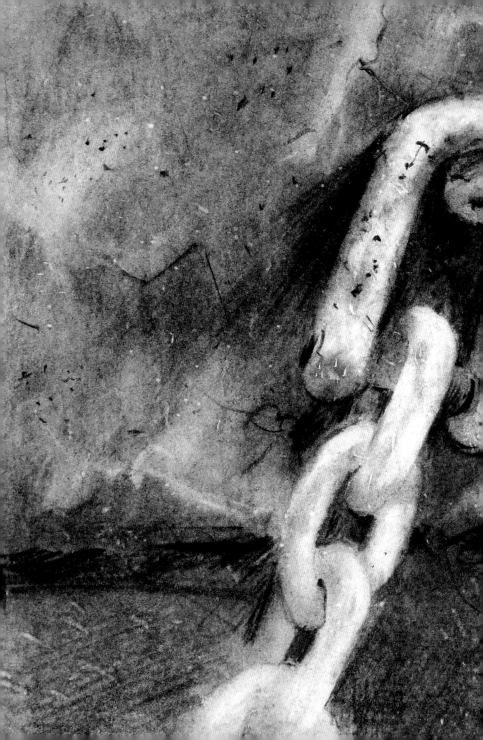

Chapter 2
Techniques

Holding the pencil

How you hold your pencil is as important as choosing the right one to use for a particular passage in your work. Take time out to practice a few of the following grips, so that they feel comfortable and soon become second nature. Try to remain about half an arm's length from your work rather than hunching over it. Make multiple lines and doodles on scrap paper, varying the pressure and tightening then loosening your grip on the pencil. In time you will find you automatically adopt the right grip without having to think about it. Take a few moments to survey your work by stepping back from it. This will also help to keep you on the right track.

The sketch grip

This is the most widely used method of holding the pencil for drawing. This technique is a little like holding a spoon, the pencil being secured by the thumb while "resting" on the first two fingers. Because the immediate area to be worked on is mainly visible and not obscured by the hand, it is also the most practical. Elegant, flowing line work can best be achieved with this grip, as can rapid blocking in of tonal areas.

Rests on two fingers

The writing grip

This is the grip of choice for writing. In drawing mode, use this grip for highly detailed passages, or where extreme precision is required.

ARTIST'S TIP
Practice the sketch grip by moving your whole arm from the elbow down; avoid relying on wrist movement alone.

Grasp here

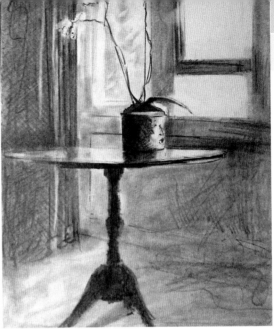

Pressure grip

When you want to shade a large area rapidly with a darker tone, the pressure grip is the one to reach for. Hold the pencil about halfway down and apply pressure to the top of the shaft with your forefinger. Work the tip back and forth across your paper using the side of the exposed graphite, taking care not to break the lead.

Apply pressure here

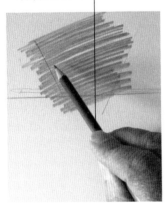

Hotel Vase
2B pencil on smooth cartridge
When time is tight and you're short on drawing materials, you can still make art. This vase and plant in a hotel room was drawn in under ten minutes using only a 2B pencil. The important information that the artist wanted to record was really concerning the tonal shifts. With only one pencil available this might have been difficult, but by utilizing a variety of grips, the essence of the scene was captured. The heavy darks were made possible with two layers of pressure-grip applications.

ARTIST'S TIP
When using the sketch or pressure grip absolute precision is not always possible. To achieve hard and straight edges, hold a ruler adjacent to the edge to be shaded and work right up to it.

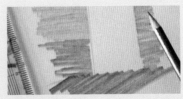

Using a ruler
Once the ruler is removed the straight edges become visible. You can see that the hatched stokes have been applied quickly and vigorously. You can tidy these edges up if necessary by going back into the line work more carefully.

Hatching

Most artists begin their picture with outlines to place the main subject matter. After you have made these outlines you can start to shade areas with the hatching technique. This may be a stand-alone finish to your work, or the basis for further development. The outline gives you the main shape and proportions, but to start to describe form or give a three-dimensional impression—thus producing a more realistic image—you will need to get into the hatching habit.

Vertical hatching

Start with an outline, as with this egg shape, and draw parallel lines in the area to be shaded. Your lines may be vertical, horizontal, or at an angle. Use any medium to apply this kind of stroke.

Crosshatching

When hatching lines are placed at an angle and over the first set of hatched lines, the technique is called crosshatching. Hatching and crosshatching are among the most widely used of all the artist's drawing techniques.

ARTIST'S TIP

Use the sketch grip (see page 56) to skim the paper surface, using either the point or the side of the graphite. Vary the weight of the line and also the distance between lines. The closer the lines are together, the darker the shaded area appears.

Curved hatching

Use curved hatching to follow the shape of a rounded object. This not only blocks in the area to be shaded, but also suggests the surface direction and form to the viewer.

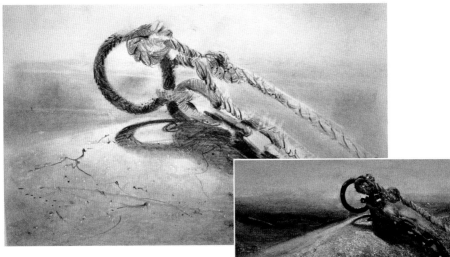

Sea Chain

B, 2B pencils on smooth drawing paper
This sea chain, braced against the elements with a taut rope made for an interesting study. Starting with an outline, and using the complete range of hatching strokes, the essence of this scene was quickly recorded for later development in the studio. Note the directional hatching strokes that emphasize the form of the surfaces.

Wind of Change

Pure watercolor
This is a studio painting following the on-the-spot sketch of the sea chain. Carrying a simple drawing kit and choosing the right techniques for the time you have available will enable you to gather all the information you need for a finished work.

Blending

Blending is an important skill to master, so is well worth practicing. The ability to produce smooth areas of tone, from the palest silver to rich darks, will transform your artwork and help take you further on your journey toward drawing excellence.

Many tools can be used for blending, including the paper stump, or torchon, tissue paper, a piece of rag, chamois leather, or even your fingers—each creates a slightly different effect. The best blending effects are achieved on smooth heavyweight drawing paper.

Using a paper stump

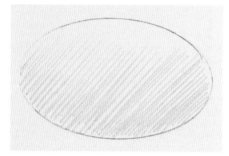

1 Start of by loosely hatching in the area you wish to blend with a 2B pencil.

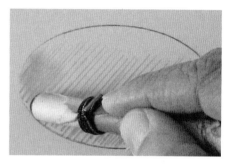

2 Use a paper stump (torchon) to blend the marks. Begin softly by stroking the pencil marks in the direction you want the blend to go.

3 The finished blend shows very subtle gradations from light to dark.

Blending with a rag

Use this blender for larger areas and apply with a circular polishing motion. Here a rag is being applied to smooth graphite and the blending gives you a real sense of the round quality of the egg shape. Notice how the upper left of the egg has been left slightly paler in the light-struck area.

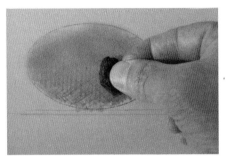

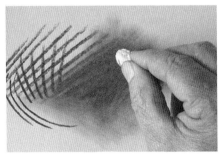

Charcoal blending

Using a blending tool is particularly effective if you're working in charcoal. Here, a piece of tissue paper is used to gently massage the hatched lines made with a medium charcoal pencil.

Blending in context

Blending to achieve form is a vital skill to master. You can take your art one step further by utilizing individual techniques, or by combining several, as in this *Old Violin* demonstration.

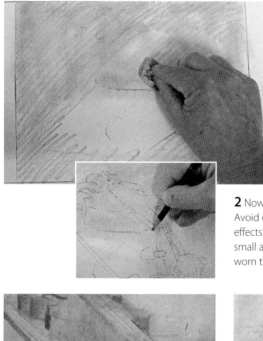

1 Start by getting plenty of graphite on the paper surface. Use a B or 2B pencil and apply with the sketching grip (see page 56), taking care not to press too hard. Aim to cover the entire paper with a mid-tone value. When the surface is covered, begin to blend with a rag in a circular motion to achieve areas of even tone.

2 Now draw in the main outlines of the violin. Avoid over-fussy detail. To exploit later textural effects you can use an incisor tool to impress small areas where the violin may have been worn through years of music making.

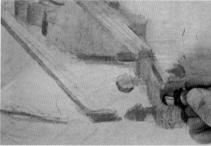

3 Next blend smaller areas of detail on the violin body with a paper stump (torchon). Remember to always blend in the direction in which the light strikes the object.

4 Retrieve areas of detailed highlight with a small eraser, paying particular attention to the area of the bowstrings. You might want to use the impressing technique (see pages 68–69) for both the violin strings and the bow area. Shading over the top with a rag or paper stump will make the white strings "pop" into view.

5 Now it's time to add more pencil shading and begin to build up the tones. Using an old eraser and a light stroking motion, blend further areas, again in the direction of light.

6 Add more dark graphite with a 2B pencil, and begin a second eraser blend.

The Old Violin

7 Add final darks with a 4B pencil and retrieve the key highlights for the reflections with the eraser, making them run toward the viewer. The subtle blends and soft highlights give a strong feeling of atmosphere in keeping with the subject.

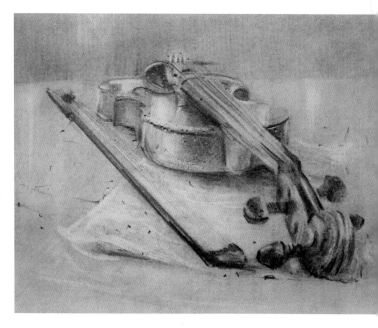

Layering

The term layering refers to the overlaying of your chosen medium on top of a previously rendered surface, usually in the same medium. Watercolor painters use essentially the same technique, which they call overlaid washes.

Use this technique to build up the subject in thin layers to establish depth of tone—in the light to middle tones, as well as the darks. Patient layering will make your work appear much more realistic.

Layering in pencil

Using the sketch grip, (see page 56) and a light to medium pressure, work across the area to be shaded in an even and systematic way. Aim for a smooth appearance, and after the first application, repeat as many times as you wish.

Achieving depth of tone

These three examples all use the same 2B pencil, and illustrate the depth of tone that layering can produce. After each layer has been crosshatched it is blended with a paper stump (torchon).

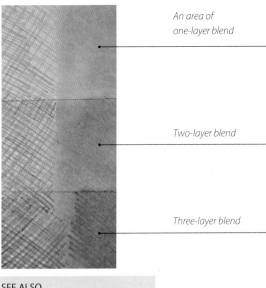

An area of one-layer blend

Two-layer blend

Three-layer blend

Ink layers

Three layers or "washes" of sepia ink have been applied to smooth drawing paper by brush. After the third layer the tonal value is extremely dark.

SEE ALSO

Holding the pencil, pages 56–57

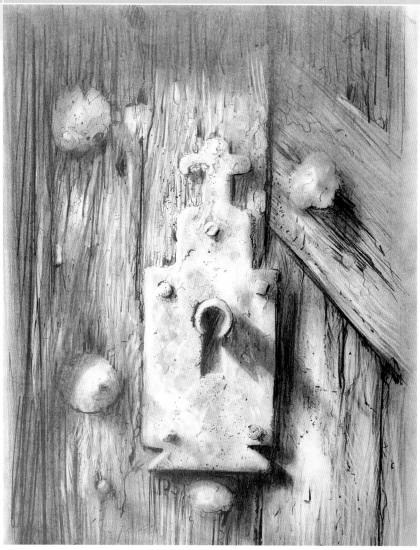

Combining Techniques

This pencil drawing, *Lock Out*, shows how the hatching, blending, and repeat layering techniques have been worked into a wonderfully atmospheric, textured finished artwork.

ARTIST'S TIP

There is no limit to the amount of pencil layers you might want to apply—you might also wish to vary the type of pencil you use, changing grades from layer to layer. Always start off light in the low B range and work toward the darkest-toned pencils.

Tonal value

Tonal value is possibly the most important single element in any work. The term "value" refers to the relationships between the light and dark shapes in any given subject, and all the shades in between.

How dark or light something appears is drastically influenced by adjacent tones. The lightest tonal value is the white of your drawing surface, which will represent your most extreme high-key value. If an element of black were placed on the paper, this opposite extreme will be your darkest low-key value. A gray tone placed between these two extremes is called a middle tone, or middle value.

The world consists of a limitless number of tones, and sometimes there is no clear delineation between tonal shifts, rather they drift into each other in a "graded" manner. As artists we usually try to make sense of what we see by reducing the number of tones in any subject into a manageable amount of gradations. It is close attention to rendering tonal changes that will enable you to represent form and achieve a sense of realism in your painting and drawing.

Pencil tones

In this example soft tones made with a rag merge into the rich darks of a 4B pencil, illustrating the incredible tonal range and versatility of the pencil.

Ink tones

Tonal marks made with sepia ink can range from almost transparent to opaque, making it a very direct and adaptable medium.

Charcoal tones

Here we see charcoal tones that drift through the tonal register, from pale grays made with a tissue through to the heaviest darks.

Mixed techniques

A rusting bolt hanging precariously on an old door provides a wonderful still-life opportunity. This subject calls for multiple techniques to achieve depth and form.

▼ Building up

A further study, this time in sepia ink, helps get to the essence of the subject. As the ink tones are laid the form of the bolt becomes clear, and the textural possibilities are also explored. Ink diluted with water provides the lightest tonal marks, which are overlaid with subsequent washes to eventually achieve the full tonal scale.

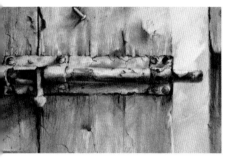

▲ Foundations

Starting with a pencil line drawing followed by a high-key passage with a B pencil, the foundations are laid for further tonal layering and rendering.

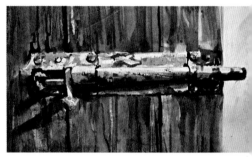

▶ Painting from drawing

Pencil and ink drawings can be finished artworks in their own right, but sometimes they can also provide all the information necessary to develop detailed paintings of the same image, as in this watercolor, Blue Bolt. Multiple layering techniques, this time in thin washes of paint, are used to achieve depth and tonal range. Note the sense of raking light that pervades the subject, an effect that could only be achieved through careful attention to the correct placement of tonal shifts.

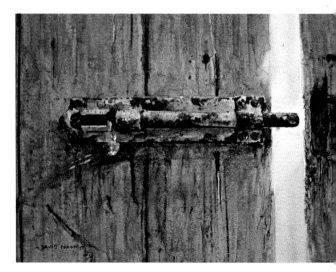

Impressing

This is a useful and enjoyable technique. It enables you to preserve the white of the paper without the need to either draw around your shapes or resort to the eraser. Impressing is best used when you wish to preserve thin lines, either singly or in multiples of hatching strokes. Experiment with using it for specific tiny highlights, for example on a textured surface such as a lace cloth or other material, even wood or metal.

To make impressed lines, you will need some form of incisor, which could be the discarded end of a pen, a blunt nail, a knitting needle, or a small hook. Having decided which detail of your drawing to leave as white, place a mat or old newspaper under your drawing paper and score it in the shapes you require, taking care not to rip the paper surface. When complete, shade over them, using the sketch grip (see page 56) and working the pencil rapidly from side to side so that it skims the paper surface. The impressed lines will "pop" into view as white paper.

Incised lines

1 Make an outline of your subject with a B pencil, avoiding fussy detail or overworking. Then use an incising tool to make impressed marks. Here, a metal allen key scores the paper surface, following the grain of the old wooden wheel.

2 After impressing the surface, hatch over the whole image with a B pencil. You can then add further layers by hatching and blending (see pages 58-61) until the full tonal register is gained. Try to work across the impressed line with your hatching rather than along its length.

SEE ALSO

Holding the pencil, pages 56–57
Hatching, pages 58–59
Blending, pages 60–61

3 Final details are added with a 4B pencil, and some of the highlights retrieved with a plastic eraser. The finished drawing shows how effective impressing can be, to not only preserve thin white highlights, but also simulate textural effects. The darker you make the background tonal elements, the more the whites and paler middle tones will stand out.

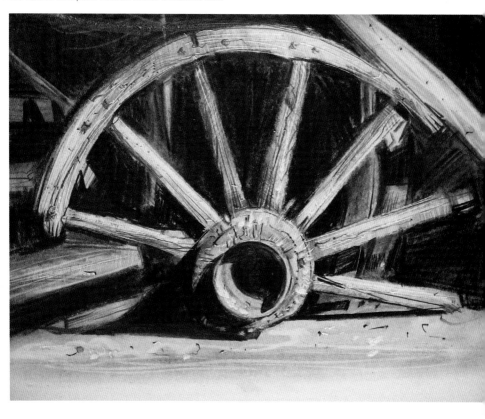

Frottage

Frottage is a little like brass rubbing—the name comes from a French word meaning to rub. It can be utilized as a means of quickly collecting information in the form of actual surface textures, or as the foundation for working over with further marks. Net curtains, a variety of fabrics, and coarse metallic surfaces or wood all offer exciting potential.

To produce the frottage, place your paper over the chosen textured surface, secure it in place with masking tape, and use either soft pencils (any of the B grades is suitable) or charcoal to skim back and forth across the surface in an even movement. You will see that the high points in the textured surface catch the pigment, leaving the "hollows" as white paper.

Wood grain

The grain of the wood shows up very clearly in the example below. It can be interesting to take rubbings from several different types of wood.

Household objects

Many objects around the house or in your toolkit can be used to make a frottage. Here a combination of buttons, spanners, and an old bolt nut have yielded exciting results.

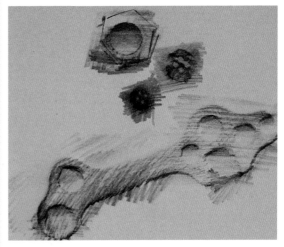

SEE ALSO

Holding the pencil, pages 56–57

Fabric

1 An old net curtain is laid onto a hard surface. To prevent slippage, secure material like this with masking tape.

2 The paper is laid in place and again fixed, and a 2B pencil used to hatch over the surface. Either a sketch or pressure grip can be used (see pages 56–57).

3 The finished drawing shows a combination of different frottage textures, forming a pleasing arrangement.

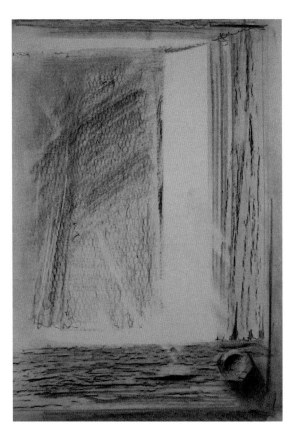

Charcoal and ink

Charcoal and acrylic ink combine well, because they are both extremely dark materials producing near-black marks, but their surface qualities are very different. The crumbly, chalky consistency of charcoal contrasts texturally with the smooth, dense appearance of the ink, and this combination can be exploited to produce interesting artwork. A further element can be added by introducing a paler tonal value by diluting the ink marks with water, thus opening up a world of creative potential.

Varied marks

Ink marks of differing intensity mix freely with the crumbly charcoal. Using a charcoal pencil you can even draw through the wet ink, thus giving even more variety to the potential effects.

Contrasting textures

Here charcoal marks have been made over the top and alongside applied ink, highlighting the contrast between the two mediums.

Quick sketches

The two mediums can be effectively used to make quick sketches. This quick sketch of a fruit bowl was made with brush and ink, which was then overlaid with medium charcoal pencil. Two-minute experimental studies of everyday objects such as this can help both your learning and creative processes.

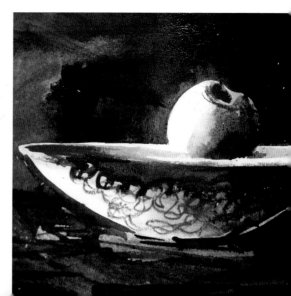

Drawing with charcoal and sepia ink

1 Make a basic pencil outline drawing of the chair.

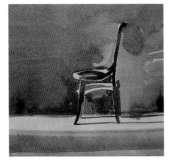

2 Pour a small quantity of the sepia ink into a palette and dilute with an equal quantity of water. Using a 1-inch (2.5-cm) flat brush, apply this middle tone to the whole surface except areas of extreme highlight.

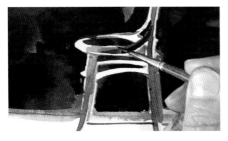

3 Use a fine round brush to draw carefully around the white paper that will represent the lightest value. It's important to work quickly before the ink dries, so have the flat wash brush at the ready to keep the ink flowing.

4 When the ink has dried, use the charcoal pencil to render the detail and the darkest areas of the chair.

5 The finished drawing is a good example of successful mixed-media work, with the tonal ink washes subordinate to the striking, opaque texture of the charcoal chair. Notice how the varied textures have been used to clearly differentiate between the chair and the background. The area where the charcoal chair legs meet the ink-cast shadows is especially important in this work.

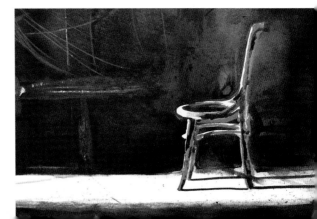

Line and wash

Some of the world's great art has been produced with a linear medium, such as pen or pencil, combined with ink washes. Capable of great subtlety in the right hands, the twin mark-making characteristics can be utilized to cover a vast tonal range and produce lovely results.

The pen and wash technique has a long history, dating back long before the introduction of pencils, but nowadays some artists prefer to use pencils with ink washes. Either medium can be put down first, or you can alternate between the two. Lines made with the pencil with a wash of transparent ink laid over them, or the other way around, can be used to describe any subject, and the method is quicker than building up tones with line alone.

ARTIST'S TIP
One factor to bear in mind is that the ink marks cannot be erased, so if you are tackling a detailed and realistic subject, make your first marks with pencil until you're sure the drawing is right.

Surface qualities
Pencil blends strapped alongside rich ink tones mix transparency with extreme density.

Pencil and sepia ink
In this flower-basket sketch, subtle pencil graduates into the dark sepia ink tones. A full range of values can be achieved even in the most quickly rendered drawing.

Mixed-media flower study

1 Using a pencil, make a light outline drawing of a flower; in this case the rose is held in the non-drawing hand.

2 Use a paper stump (torchon) to blend all the petal edges and shadows into soft gradations, and reclaim any lost white paper with a plastic eraser.

3 Apply washes of diluted ink (approximately 50:50 ratio) over the pencil drawing. Preserve any white paper that you wish to retain to represent your extreme highlights. When dry, reinforce with further ink where necessary. To complete the drawing, add a few darks with a 4B pencil over the ink tones. Apply touches of further detail using a twig dipped into undiluted sepia ink.

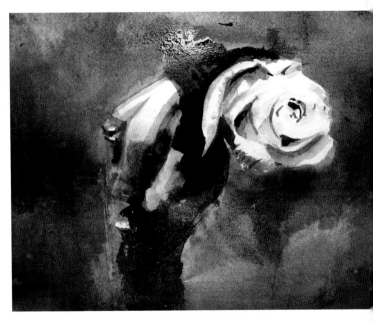

Laying a wash

As in watercolor work, one of the necessary techniques you need to master is that of laying a wash. This simply means applying a small or large area of ink to your paper to fill it with tone. The darkness or lightness of the wash is determined by how much water you add to the ink, and what type of ink you use. To practice the method you will need water-soluble drawing ink, water, and a 1-inch (2.5-cm) flat brush.

1 In an old saucer or palette, place a small amount of ink and mix it with an equal amount of water.

2 Place your paper on a drawing board and prop it up at a slight angle. This encourages the ink to run down the paper and give an even area of tone. Dip the brush in the ink and take it horizontally across the surface with an even pressure, starting at the top. Recharge the brush and apply a second stroke immediately under the first, but with a slight overlap. This is to pick up any beads of ink that may have formed. Repeat the process until the paper is covered.

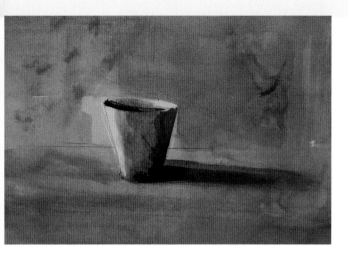

3 Once the first wash is dry, experiment by overlaying further washes. To gain depth of tone, try leaving parts of the first wash exposed and painting around them.

Building form
In this version of the same bucket sketch, multiple washes of dilute ink have been used to render form and tonal value.

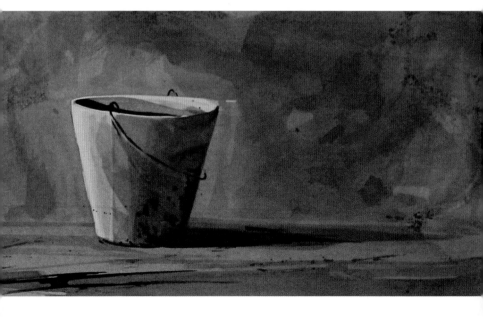

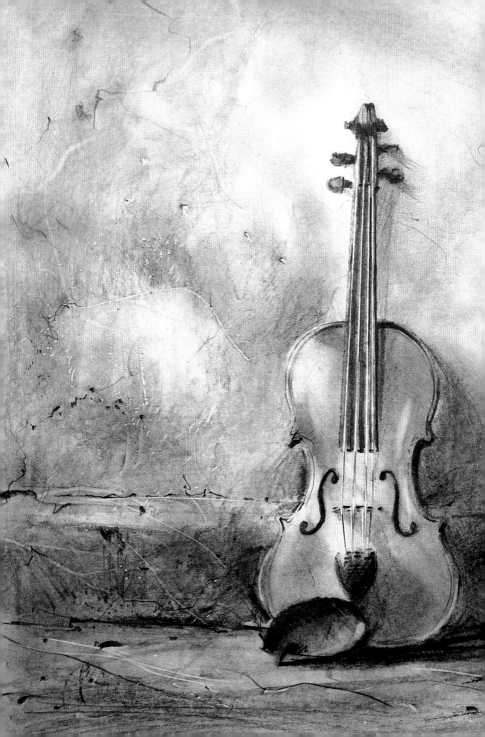

Chapter 3
Making pictures

Seeing and looking

We see things all the time, but seeing is not the same as really looking. As you develop as an artist you will subconsciously begin to see the world differently, feeling an immediate emotional reaction when a potential subject is encountered. This is because artists will visualize the scene not as it actually is, but as it will appear on a two-dimensional surface. In order to do this you need to analyze your first reaction, looking hard at the subject to make sense of the interlocking shapes, lights and darks, textures, and so on, and working out how best to get it down on paper. Walk around your subject and if you can, touch it to feel the forms and surface textures. Squinting with one eye closed will help you work out tonal values, because this reduces the impact of color. Decide what the nearest element is and where would be a good place for your picture to start and end.

Counterchange

As you develop your ability to look you will notice that the subjects before you are not just influenced by size and spatial relationship, but also by tone and form. To make sense of this you will need to impose some artistic order, and the principle of tonal counterchange is a great help. A middle-toned object will be light where it overlaps a darker object, but if the same object then crosses over an even lighter surface, it in turn will appear darker. Examples of counterchange are all around you, and can be used to good effect to make your drawings both more realistic and more powerful.

The importance of backgrounds

This pencil drawing clearly shows counterchange at work. The bottles on the right side are set against the light source and have been given mainly a middle-tone treatment, while those on the left are set against a dark backdrop and have been given a reversed negative treatment by using high-key tones. All the bottles are effectively the same, but the background setting completely alters how we view them.

Surface texture

Sometimes subjects that do not immediately demand our attention have an innate beauty mirrored by their humble setting. This old chain tied to a sea wall is the type of unpretentious still-life subject that could be easily missed, but a closer inspection reveals a world of surface texture caused by years of weathering.

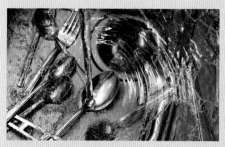

Unusual subjects

This image of the washing-up bowl might not be everyone's idea of a good subject, but as an artist you will start to look more closely at everyday scenes, and here the very random arrangement of the cutlery makes for dynamic compositional potential. This is natural abstraction, which is not devised in any way; the broken water surface distorts the outlines, with objects appearing to dissolve into the liquid.

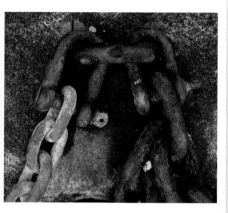

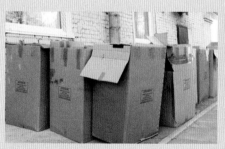

Telling a story

A bunch of boxes await collection—or have they just been delivered? Are the contents needed, or have they been discarded? By tuning in to a possible story behind the immediate surface image you will engage the viewer's interest as well as giving your work a deeper meaning.

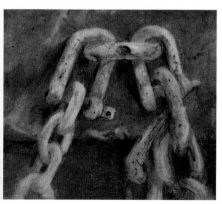

Texture study
Aged by the salt wind and crashing sea, a close up study reveals a hidden world of texture and beauty in this old harbour chain.

Collecting props

One great advantage still-life artists have over landscape artists is that they never need to be dependent on the weather, so start to collect items of interest so that you can indulge your creative passions in the studio on rainy days.

Items that have been discarded by others, usually past their best after a lifetime of use, can provide extremely good subjects to tackle. Old garden tools, discarded kitchen utensils, the remnants of a garage sale, a box of old jam jars, all these objects have a story to tell. Try also collecting natural forms such as stones or rocks; beachcombing at the shore-line is an excellent place to hunt for stimulating subject material. Thrift shops can provide a good source for future masterpieces. An old coat or a pair of shoes, once the height of fashion and now rejected, could become a poignant visual essay on how the passage of time affects popularity.

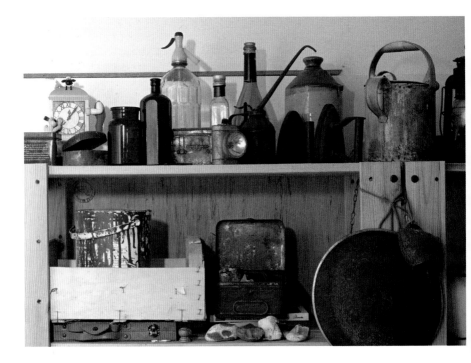

Still-life collection
The author's studio is crammed with interesting objects. Age and hard wear make them even more appealing as still-life subjects.

◀ Inexpensive objects
This type of enamelware was very popular years ago and is relatively easy and cheap to acquire.

30 IDEAS TO START YOUR SUBJECT COLLECTION

1. Shoes
2. Walking and work boots
3. Coats
4. Hats
5. Bags and suitcases
6. Scales and weights
7. Ropes and string
8. Figurines
9. Clocks and watches
10. Jars
11. Glass bottles
12. Sewing machine and sewing kit
13. Used paint tins
14. Garden tools
15. Weathered wood
16. Sea shells
17. Keys
18. Glass bowls
19. Pebbles and rocks
20. Cups and saucers
21. Old metal and chains
22. Net curtains
23. Fishing rod and nets
24. Plants and plant pots
25. Wooden boxes
26. Old tools
27. Books
28. Table lamps
29. Musical instruments
30. Dried flowers and seed pods

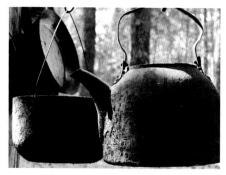

▲ Old kettles, pots, and pans
Kitchenware offers a range of shapes and surface qualities for the artist to explore.

▼ Bottles
Collect interesting bottles whenever you can, since they are always a good standby subject and the cylindrical shapes and forms provide valuable drawing practice.

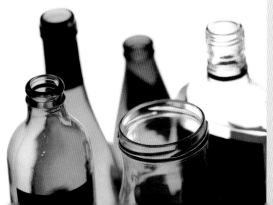

Composing a still life

The choice of compositional format is not totally reliant upon your chosen subject, so when you have set up a still life, try to imagine it as you might a stage set. Upon this stage you will place various characters, some more important than others. Think back to why you were inspired to tackle a particular theme, decide who your main "character" will be and position it accordingly. Ask yourself whether the "star of your show" deserves to be a solo performer, or does he require a supporting cast of other performers? Will it be a group effort?

Arranging your choices

This sequence of images illustrates a few tips to help your compositional choices.

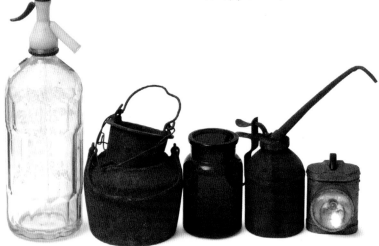

BACKGROUNDS AND SET-UPS

Once you have your choice of combination in place, it's time to pause and think about the background. This needs to be sympathetic to the type of subject and style of your work. Part of your prop collection might consist of old curtains or fabrics; these are always a good standby as background materials. You may have positioned your work on a central table or podium that will enable you to tackle the theme from any direction, in which case deciding on a background is trickier, as you are faced with an expanse of space—though the space might be needed to complement the theme. Setting the group against a wall will enable you to experiment with artificial lighting effects, while placing it against a window can give exciting against-the-light effects. Your set-up will be naturally affected by the changing light conditions, but momentary shafts of natural light may be inspiring in their own right (see Lighting, pages 90-91).

◀ In this arrangement the composition is unbalanced. The cycle lamp is "lost" within the outline of the oil can. The spouts of the soda siphon and oil can are at opposing angles.

▶ Positioning the largest item at the front is not a good idea since this means the supporting objects are lost or hidden from view.

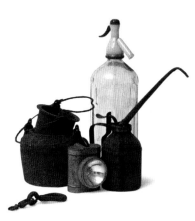

▲ This is a better composition. The objects are more naturally grouped, and the shapes interlock. The addition of the supporting key in the foreground provides a directional lead into the focal point, but does not compete with the main grouping.

◀ This arrangement fails because the blue jar, lying on its side, steers the eye out of the frame. Additionally, the remaining objects are separated from the jar and positioned in too orderly an array.

ARTIST'S TIP

When you are setting up your still life consider the number of objects to use. The end results will be more stimulating if you either work on a single object, or groups of objects in uneven numbers, i.e. 3 or 5.

▶ Ask yourself whether your objects actually belong together in the same picture—is there some relationship between them? This composition might work because of the related textures, although there is still some imbalance due to the angles of the oil can spout and glue pot handle.

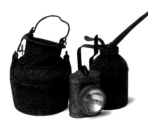

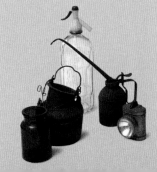

Choosing the viewpoint

When drawing any subject, you need to locate the most advantageous position, or viewpoint, in order to extract the essence of the scene. In the case of still life this may not always be possible. For example, you may have restricted access to a subject, perhaps looking through a doorway or window at a target subject, but for a studio set-up you have total control, and can decide on the best angle of viewing.

Either during or after setting up your subject, view it from a variety of angles. Sitting, standing, or reversing the view entirely by looking at the set-up in a mirror—this mobility will aid your creative flow. Pay attention to any foreground elements that may be required to give further focus to your main object, and add or take away until you are ready to fix your working position.

Sometimes the most unlikely angle provides the best dramatic possibilities. Here your viewing angles will also be greatly influenced by your choice of lighting. Don't be afraid to experiment and mix surface textures, and note the effect a change of view has on the objects.

Finding an angle

After setting up the still life, your own drawing position (your station point) will have a major effect upon the art you produce.

In this angle of view the bear is staring straight at you, and the other objects are nearly obscured. The angle makes the image too compressed.

The bear is now peering out of the frame, which is not ideal, because this conflicts with the direction of the watering-can spout.

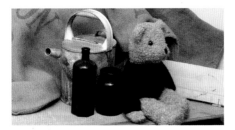

Emphasis has now been shifted and the bear becomes a supporting character, with the two bottles competing for our attention.

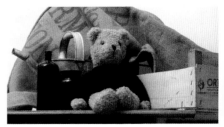

This low angle adds drama to the composition. The back drop of the old sack links the elements, and the interlocking shapes complement one another.

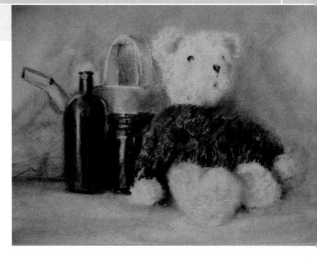

Low viewpoint

The old teddy bear belonging to the artist's daughter now lives in the studio, and introduces some real character to this composition. He is the main focus, but the supportive positioning of the bottles and old watering can provide contrast and scale. The low angle of view, with the bear seen at eye level, ensures that the main character is given the prominence he deserves.

Exploring possibilities

A wonderful old wagon with a cargo of baskets and wine flagons provides numerous found-subject possibilities. You could take in the whole atmospheric scene, or zoom in on an area of special interest and concentrate on specific details and textures.

FOUND SUBJECTS

Sometimes you will see a subject that requires little or no rearrangement, although of course you can still affect the composition through your choice of viewpoint. These "found" subjects can be outdoors or in. A wheelbarrow in a park or garden might fire your imagination, as might a chair by a window or a collection of crockery on a kitchen table, so always be on the lookout for possibilities. These subjects often make for the most successful paintings or drawings, because there is something about discovering an object in its natural environment that no amount of effort expended in the studio to reproduce a set-up can imitate.

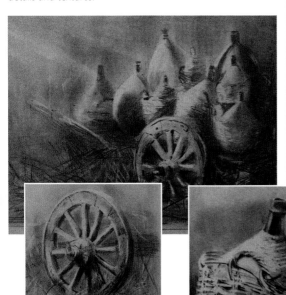

Designing the picture

Deciding where to place your subject on the drawing surface is the first step in designing the picture, but it is not quite as easy as it sounds, and has occupied artists throughout the history of art. First decide whether your subject is better placed in a portrait format (upright rectangle) or landscape (horizontal rectangle). Rectangles are most often used, but some subjects may benefit from a square format. Your intention should be to create the most pleasing arrangements of the shapes you have decided on.

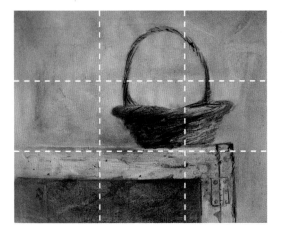

The rule of thirds

There are two well-tried theories that could help you in your picture design, the first being the so-called "rule of thirds." Divide your paper into thirds both horizontally and vertically, and position your key subject material on or close to any of the intersecting lines. Next place all the other subject elements that make up the composition. This simple layout device gives a very effective result, with the positions of greatest impact being those where two lines intersect each other.

The golden section

First devised by the ancient Greeks as an architectural planning aid, this mathematical formula produces interesting aesthetic possibilities for the artist. The idea is to divide your picture plane into a ratio of 5:8, and place your focal point (main center of interest) on or near the division. Leonardo Da Vinci's *Mona Lisa* uses this very design. This ratio is commonly found in nature, for example in the spiral design of the lovely nautilus shell, as well as in flower petals and pinecones.

Center of interest

5:8 ratio

5:8 ratio

Placing your focal point

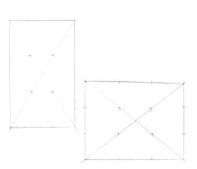

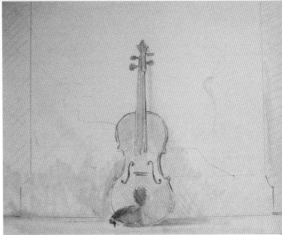

1 These sketch diagrams show two ways to work out where to place your focal point – in this case a violin.

2 Positioning your focal point in the center of the picture plane may appear at first an obvious choice, but the equal-sided design does have limitations because the spaces on either side compete unnaturally for our attention.

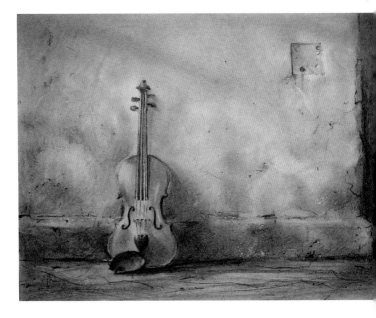

3 The violin has now been positioned on the left side intersecting lower third. This gives greater dramatic impact and results in more atmospheric design potential.

Lighting

Working in the studio gives you a number of advantages that will help you to create powerful imagery. The most important is that you have total control over how the subject is lit. There are several varieties of indoor lighting source. The first and most obvious will be natural light entering the interior from outside. This is of course less controllable than artificial light, but can be modified to a certain extent by using curtains, slatted blinds, or any other means to steer the light onto your subject. In some cases the subject can be moved to take advantage of the natural light.

The interior of the room itself may be the basis for your still life, and will therefore be affected by the quality and changes of light invading the scene.

An artificial light source provides your greatest area of control; this need only be a simple, inexpensive spotlight. Experiment with different lighting effects, as some of your most exciting and creative compositions could come from the way the subject is lit. A spot positioned close to it will produce the greatest contrast possibilities, while a more distant source will give an ambient, softer effect.

Ambient light

This teddy bear was positioned on a chair by the studio door, and lit from the right by ambient daylight, catching the top of the armrest and some of the curly fur. This gave just enough illumination to enable good form definition.

Spotlight

In this case, there is some north light entering the working area, but the main source of light is from a spotlight positioned to the left of the subject. Soft shadows wrap around the lamp providing the landmarks necessary to describe the form. As the light source will not change, time can be taken to observe its effects.

SEE ALSO

Holding the pencil, pages 56–57

Changing the light source

By way of contrast, the subject was moved into daylight and placed in front of a wooden box. There was no bright sunlight to contend with, as the weather was overcast, giving more time and opportunity to make an atmospheric study.

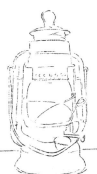

1 A quick line drawing of the lamp made with a B pencil on smooth drawing paper provides enough information to make a start.

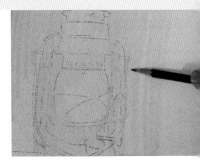

2 The whole surface area is then blocked in using the pressure grip (see page 57). Three subsequent layers of graphite are then added.

3 Each pencil layer is blended with a small rag, and edges are softened to reflect the gentle nature of the outdoor light.

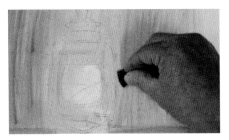

4 A flexi-curve is used to ensure that the curved lines are rendered accurately.

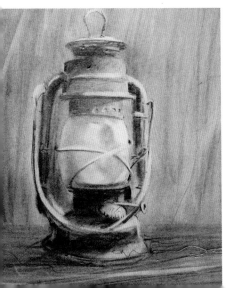

5 After detailed work on the lamp and background, the drawing is finished. There is a distinct difference in mood between the two drawings of the lamp. The first drawing, opposite, has an intimate atmosphere as a result of the direct light source, while the generalized surface lighting used for the second study produces a different, more tranquil quality, without loss of form or definition.

Cast shadows

One of the artist's most valuable skills is the ability to analyze and draw cast shadows, because it is these that help you to place the subject in its spatial surroundings. Shadows are not just black shapes; they can vary from subtle gradations of tone to rich, deep darks.

As a general rule, the shadow is cast from the side of the object that is opposite the light source, and the area of darkest dark is at the point where it leaves the object. Shadows cast on one object by another provide the artist with an extra benefit, and can help describe the form of the object receiving the shadow.

Blending and softening shadows

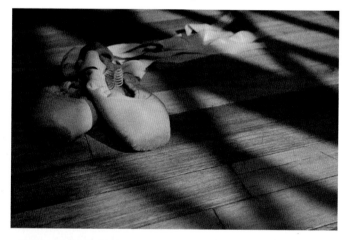

1 These discarded ballet shoes are struck by a light source on the right. An outline drawing is made of the shapes, including that of the cast shadow, which curves and follows the form of the second shoe.

2 The main blocks of tones are hatched in with a B or 2B pencil.

3 A paper stump (torchon) is used to blend the shapes to a smooth, even tone. The tones are then built up with further hatching and blended again, paying special attention to softening the shadow edges.

4 Now a 4B pencil is used with heavy pressure to draw the points of darkest dark where the shoe meets the shadow. This adds drama and scale to the shadow shape. Notice that where the black line meets the shoe, the edge has been left as a faint highlight.

5 Multiple shadows, from the shoes and also from "off stage," give an extra element to this atmospheric subject. Following the shape of the shadows describes the form, and in this case the shadows also help to unify the composition.

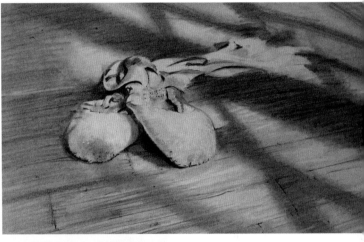

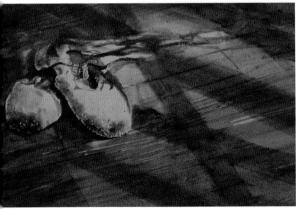

Stretching the shadows

In this interpretation of the same subject, this time in sepia ink, the off-stage cast shadows have been stretched out to provide a "wide-screen" format. The brightest highlights have been created by leaving white paper, and some of the texture patterns at the front of the shoes have been created with a thumbprint.

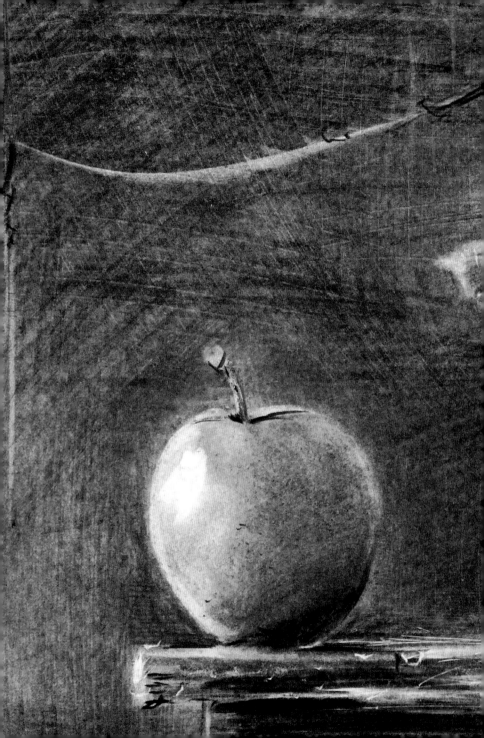

Chapter 4

Drawing in context

Still life in landscape

Abandoned cars sit in a giant field, becoming part of the landscape they inhabit, with a hint of the vast panorama beyond giving a feeling of desolation. These once-proud machines are being reclaimed by the very earth they traveled over. This would be an excellent subject for any medium, but in this case ink is used.

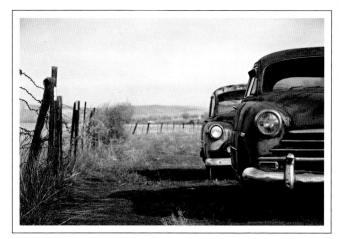

MATERIALS AND EQUIPMENT

Smooth heavyweight drawing paper
B pencil
Sepia ink
No. 7 synthetic brush
Old hog-hair brush for spattering
Small twig for mark making
Tissue

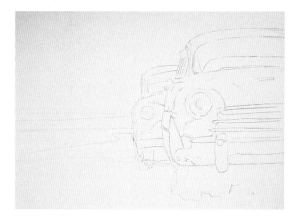

1 The artist has decided to remain faithful to the reference image, so little of the composition is rearranged. The cars sit to the right of the picture plane, which will need care later on to ensure a balanced piece of work. A quick outline drawing is made with a B pencil to plot the main shapes.

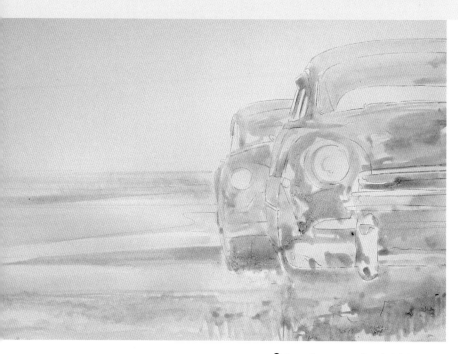

2 A small amount of sepia ink is poured into an old saucer. This is diluted with approximately the same amount of water. Starting at the sky, a synthetic brush is used to paint a pale wash over the whole paper with the exception of the extreme highlights, which are left as white paper.

3 With the ink still wet (you have to be quick here because it dries quickly), a hog-hair brush is dipped into the same ink mix, then held close to the paper. The bristles are flicked toward the surface, spattering the car hood with ink drops to simulate rust spots. The inks are then allowed to mix and texturize. When spattering, make sure you protect the areas you do not want to cover in ink spots.

4 Now it's time to firm up the drawing. Using undiluted ink and a small twig, areas of the car that need darker tones and some line drawing are painted in. The twig allows you to create an interesting textured effect that is perfect for this type of subject.

5 Additional washes with the diluted ink are applied to the shadowed side of the car, and also the landscape and ground plane. The darkest darks are placed with undiluted ink and the synthetic brush.

6 Another wash is laid to reinforce the middle tone and darkest areas. While still wet, a tissue is raked across the surface from right to left, leaving the ground shadow in position.

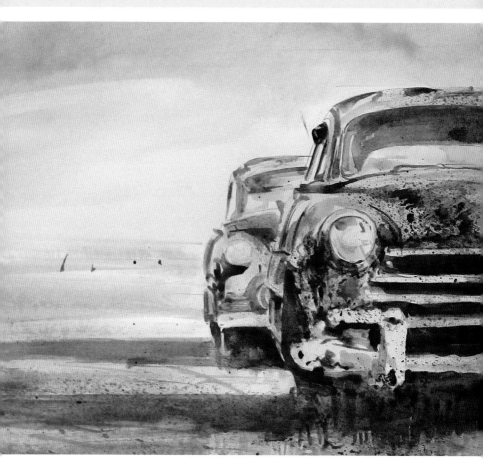

Rusting Cars

7 For a finishing touch, a row of fence posts receding into the distance was drawn in using the twig. This leads the eye back into the composition and restores the balance and harmony of the piece.

Studio set-up

This is a subject composed in the studio, with the objects placed on a board resting on a chair. The reference image shows the scene under normal daylight conditions, in contrast to the drawing, for which a spotlight is used.

For the purpose of the drawing, and to inject some drama into the scene, a small spotlight was placed at the same level as the chair, pointing up at the subject from the lower left.

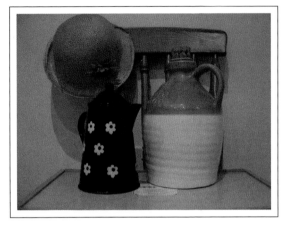

MATERIALS AND EQUIPMENT

Smooth heavyweight drawing paper
Pencils: B, 2B, 4B
Paper stump (torchon)
Plastic erasers: standard size
and small
Old brush

2 Using the B pencil and the pressure grip with the forefinger placed on top of the shaft (see page 57), most of the paper surface is hatched in. Special care is taken around the edges of the hat, where the white of the paper needs to be preserved.

1 An outline drawing is made with a B pencil, using an imaginary grid.

3 After the first blocking in, the tones are smoothed and blended with a paper stump, before a second application of graphite is applied with a 2B pencil. This is again blended.

4 The blend follows the direction of the grain on the chair, and also the curves in the pot, jug, and hat rim. The cast shadows on the jug help to describe its form.

5 A third application of tone with the 2B pencil, followed by another blend, starts to give real depth to the subject.

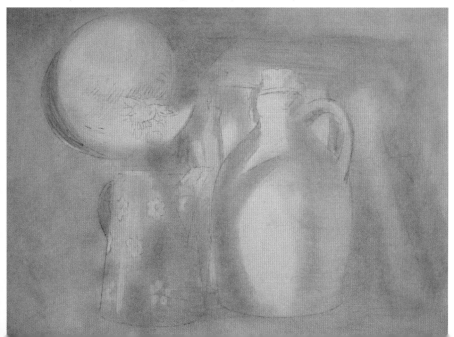

6 Some highlights on the jug area have been lost slightly and need to be retrieved. The shadow edges are tidied up with an eraser, and the residue is brushed away with an old brush to avoid possible smudging.

7 Highlights on the straw hat are retrieved with the same eraser, and a smaller one is used to lift out small highlights around the hat decoration.

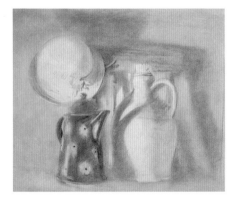

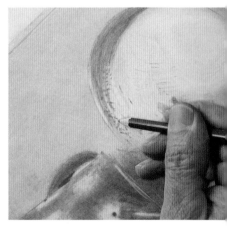

8 The 4B pencil has been used to place the darkest marks on the coffee pot, and in the extreme shadow areas under the base of the jug. Note how the shadows vary in tone, and how they start to link the components together.

9 Small details are placed where required to simulate the weave of the hat, and around the flower pattern on the pot.

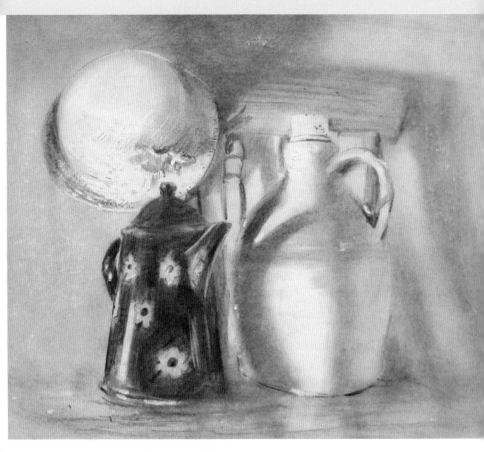

The Three of Us

10 The completed picture shows a pleasing arrangement brought to life by the dynamic light source. The cast shadows describe form and give the image unity and cohesion. Note the tiny highlights left on the curved edges that disappear into the darkest shadow areas. It is when you start to notice this type of detail that you realize you are not just seeing but really looking.

Restricted access

Sometimes it is not possible to get close enough to a potential subject to be able to explore all the possible viewpoints. This fountain, in the Bath Pump Room, England, dispenses thousands of gallons of natural spring water every day for those wishing to "take the waters." Its lovely classical shape, the carved fish with gaping mouths, and its historical associations, made it a tempting subject, and the fact that access was restricted added an extra challenge.

MATERIALS AND EQUIPMENT

Smooth drawing paper
Pencils: B, 2B, 4B
Sepia ink
No. 7 synthetic brush
Paper stump (torchon)
Incisor tool
Rag
Plastic erasers: standard size and small

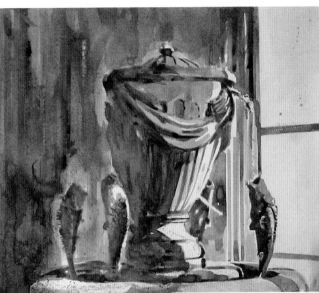

1 The initial drawing is a tonal study in sepia ink over a pencil outline. This has the twin advantages of being quick to do, as well as providing a "rehearsal" of the tonal shifts that will help in the later drawing.

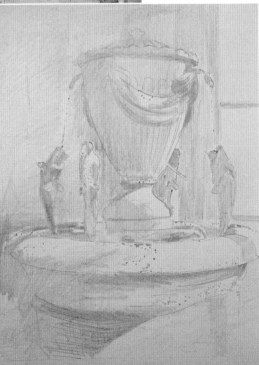

2 After an initial line drawing, two consecutive block-ins with B and 2B pencils, followed by blending with a paper stump, established all the high and middle tones. An incisor tool (an allen key in this case) is used to stipple the area around the urn base and pedestal. This light impressing will provide an option to add texture effects later on.

3 Most of the surface area receives a further hatch and blend with the 2B pencil.

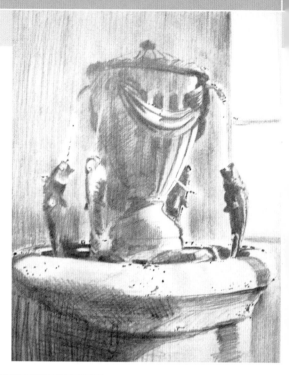

4 Special care is taken to draw the fish shapes accurately. Now it's time to establish some really dark areas with a 4B pencil. Another pass with a 2B pencil is made in the background, and is then blended with a rag.

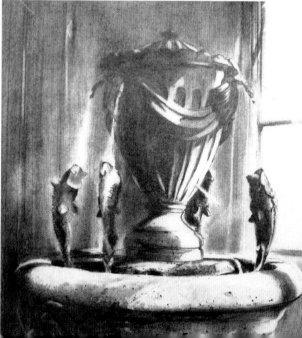

Spring Water

▶ **5** In the final stages more darks were added with a 4B pencil, followed by eraser work to both establish the highlights and help describe the form of the subject. The hatching over the earlier incised marks has produced a textured effect that gives a real feeling of the ancient stonework.

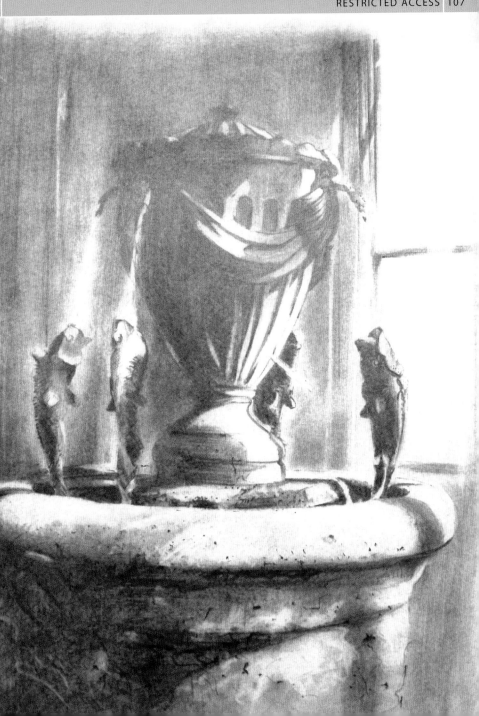

Single-object still life

Standing in the spotlight, an old-fashioned radio mike almost takes on the persona of a solo performer. The subject is positioned on the right-sided third (see pages 88–89), with the focal point at an intersection, an area that demands our attention. This is where the lightest light and darkest dark will be placed for maximum impact.

MATERIALS AND EQUIPMENT

Smooth heavyweight drawing paper
Pencils: B, 4B
Incisor tool
Rag
Paper stump (torchon)
Plastic eraser: standard size
and small

1 Working in portrait format, an outline drawing is made with a B pencil. The mike is positioned over the right-side third line, aiming to get the best highlight close to the top intersecting third.

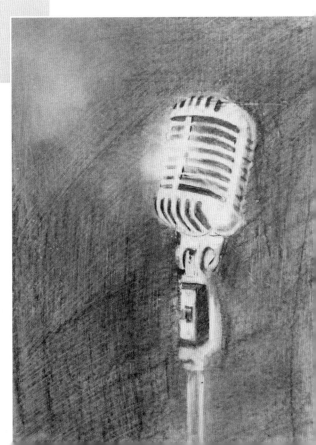

2 The whole surface is blocked in with a variety of hatching strokes using the B pencil and the sketch grip (see page 56). Although the theater is in darkness it is not all black, so the artist aims for a variety of dark tones with a gradual build-up in layers.

3 The mike is carefully drawn around and treated as a "negative" near-white shape against a "positive" dark background. This is an example of counterchange (see page 80). At this stage only areas of shadow are being filled in, just enough to give a sense of form.

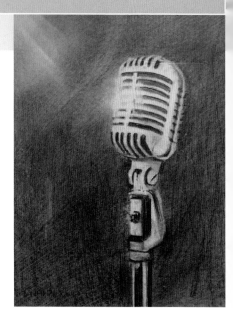

4 The background is lightly scored with an incisor tool (in this case an allen key), as are the edges of the mike, then further tones are hatched over and blended with a rag. This will give the dark areas a little textured finish to enhance the atmosphere.

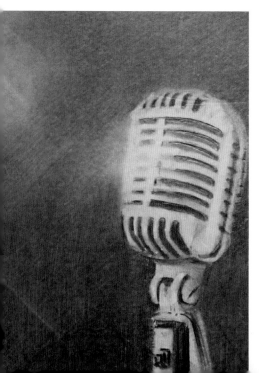

▶ **Starring Mike**

5 More darks have now been added, using a 4B pencil. These were blended with the rag in the background, and with a paper stump on the mike. A sense of the light source in the top left area has been gained by lightly stroking the paper with a plastic eraser. As hard edges were not wanted, these were gently blended away, and finally extreme highlights were picked out on the mike with a small, clean eraser.

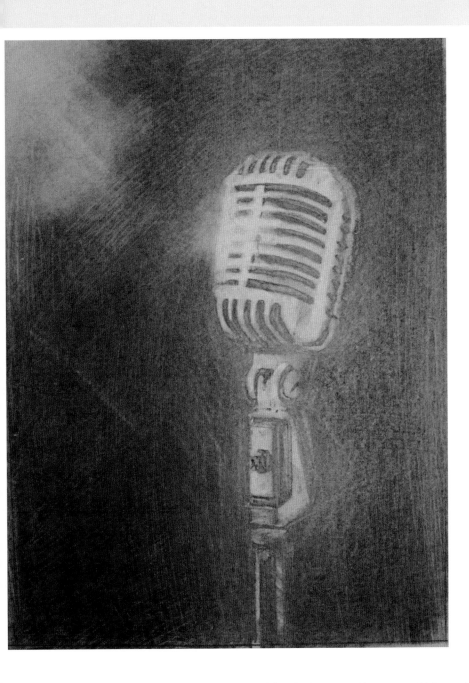

Texture as a subject

Sometimes the essence of a subject lies not in the object itself but in the character of its surface textures. These can be beautiful in their own right, providing an opportunity for a real "workout" of mark-making techniques. For this demonstation a watercolor painting provides the inspiration. The peeling paintwork and weathered wood, precariously held together by a few old nails, make this an ideal subject for the artist to explore.

MATERIALS AND EQUIPMENT

Smooth heavyweight drawing paper
Pencils: B, 2B, 4B, 6B
Incisor tool
Old paintbrush
Rag
Paper stump (torchon)
Plastic eraser

1 A speedy line drawing, mostly vertical and horizontals, places the main divisions between the wooden planks. For added effect, a window to the left of the picture plane is included.

2 With an incisor tool (in this case part of an old belt buckle) the surface is impressed along the grain lines of the wooden planking.

3 Next, the surface is randomly dotted and indented with the reverse end of an old paintbrush. Place a mat or an old newspaper under your paper before tackling this stage.

4 The whole surface is now blocked in with a 2B pencil. A variety of hatching strokes is used to do this, following different directions.

5 The rag is now used to work the graphite into the paper surface. Bear in mind that you are trying to simulate years of weathered surface, so vary the pressure and directions of your blend as if you are actually "feeling" the surface. Now go again with more graphite, picking up details here and there to emphasize the texture and cracks, then blend again.

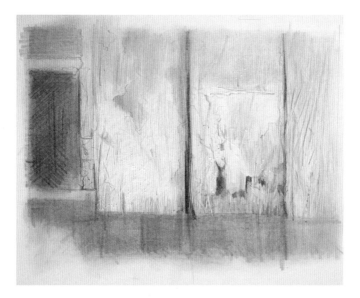

6 Extreme darks in the window area have been put in with the 4B and 6B pencils and blended with a paper stump before applying more layers of graphite. Details of the peeling paint have been picked out where needed, and the dark shadows that separate the planks given extra emphasis.

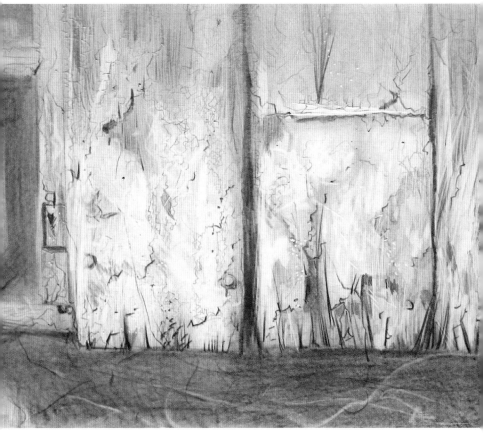

Northside

7 Parts of the drawing were tidied up, and lost highlights retrieved with a plastic eraser. Finally, using the 4B pencil, areas of heavy dark were added to the underside of the windowsill and woodwork.

Composed still life

Three apples on an old table are seen at eye level, lit from the left by an artificial light source. This is a composed rather than a found subject, and one you can easily replicate with any of your favorite fruits or vegetables. The background is a dark mix of blurred shadows without any definition, and this will be used to emphasize the sharp-edged lights and middle tones where the light illuminates the fruit.

MATERIALS AND EQUIPMENT

Smooth heavyweight drawing paper
Pencils: B, 2B, 4B
Incisor tool
Rag
Paper stump (torchon)
Small plastic eraser

1 After making a horizontal line to represent the tabletop in the lower third of the paper, the apples are positioned with an outline in B pencil.

2 An incisor tool (an allen key in this case) is used to impress the paper along the edges of the old table. This will provide textural options later. A few light impression marks are also made along the apple stalks, and at random points in the background.

3 The background is now begun with varied hatching strokes using a 2B pencil. You don't want a solid black area, so frequently change your angle of attack. Rotating the paper often helps you to make these areas look more interesting.

4 After each pass with the 2B pencil, the graphite is blended to a blur with a piece of rag, using a variety of movements and pressures. This will all help to give the illusion of dim light trying to penetrate a dark room.

5 Work now begins on the apples, and tones are blended with a paper stump (a more precise blending implement than the rag), following the curves of the apples in the direction of light. Soft hatching strokes are added until the tones become progressively darker, then blended again. Repeat this process until full value has been obtained.

6 A small plastic eraser is used to retrieve some of the critical highlights on the apples. Try to keep hard white edges to a minimum, using them only at the points where you wish to give the greatest impact.

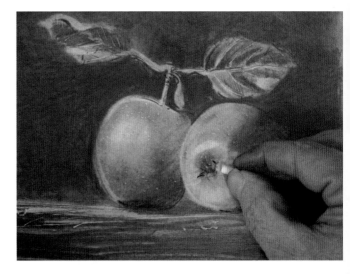

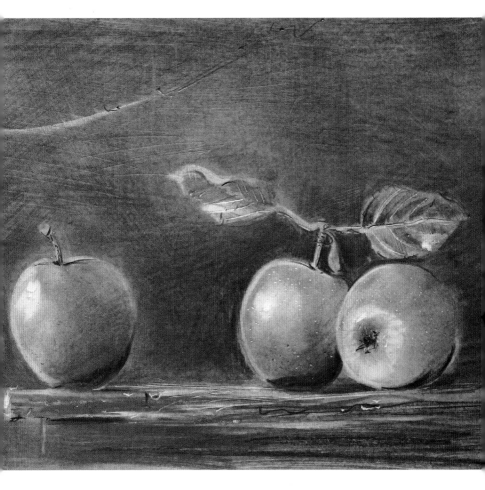

Apples

7 In the final stages a 4B pencil was used to add the darkest marks to the apples—notice how the tone varies where these darks meet their cast shadows. As the apples disappear away into the gloom, a few strategic highlights have been regained, helping to define the forms.

"Found" still life

An elegant chair stands by an open window in a hotel room. A cascade of light pours in, providing an evocative and exciting found subject that the artist needs to get down onto paper quickly before the bright light disappears.

While you have less control over these "found" interior set-ups than with the classic still-life subject, interiors are usually given a special charm by a particular lighting effect. This charm is worth recording.

MATERIALS AND EQUIPMENT

Smooth heavyweight drawing paper
B pencil
Charcoal pencil, medium grade
Rag
Kneadable eraser

1 An economical line drawing is made of the chair, and the window is lightly sketched in to place it in context.

2 A charcoal pencil is used to make a "pool" of charcoal on a piece of scrap paper, by scribbling around in circles.

3 A small rag is dipped into the charcoal pool.

4 For the lightest tone, the white of the paper is to be preserved as much as possible. The rag with the crumbled charcoal is now stroked across the paper surface in the direction of the falling light.

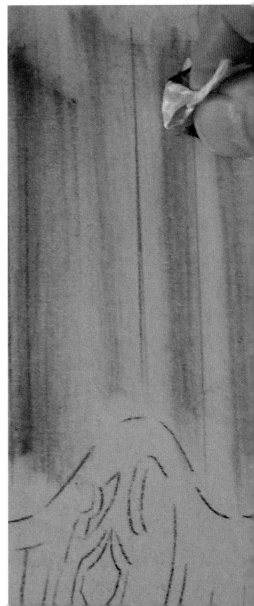

5 After the rag application, a soft middle-tone value covers the entire image except the lightest areas, which remain as white paper.

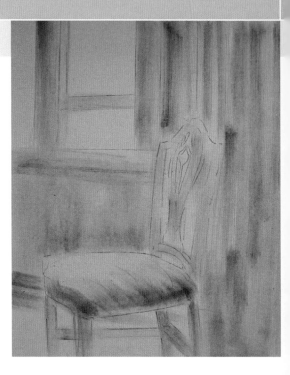

6 It is now time to apply the darkest darks, and also to firm up the drawing. The curtain is hatched in, as is the chair itself. A residue of charcoal has invaded the white areas, and these are retrieved with a kneadable eraser, following the direction of the light rays.

▶ *Chair by a Window*

7 A final pass with the eraser has been made to tidy up the drawing, and the edges of the window have been softened and "lost." This enhances the impression of bright morning light pouring into the room. Notice that the edge of the chair nearest the window has been given similar treatment.

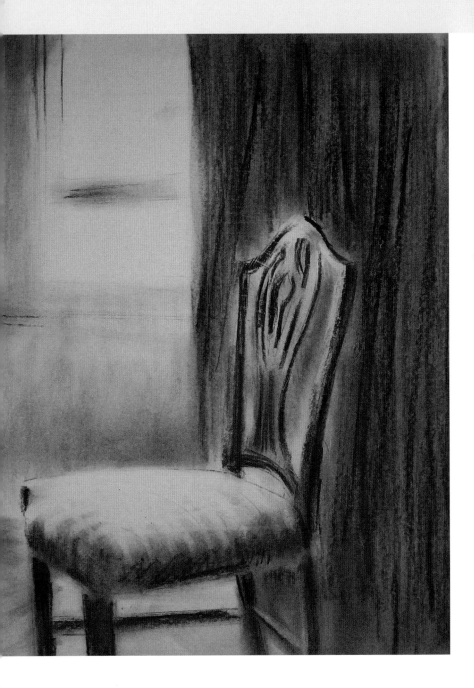

Focusing in: Selecting a detail

For this subject, a noble warrior in Classical style, the artist has chosen to zoom in on a detail of the side-view head, which is lit by ambient light flowing in from the front right.

MATERIALS AND EQUIPMENT

Smooth heavyweight drawing paper
Pencils: B, 4B
Incisor tool
Paper stump (torchon)
Acrylic sepia ink
1-inch (2.5-cm) flat brush
Synthetic brush
Tissue

1 An outline drawing is made with a B pencil, and the carved-stone hair curls are loosely described. Make your line work soft at this stage, particularly on the edge of the nose. Use an incisor tool (an allen key in this case) to add some random texturing effects for later impressing.

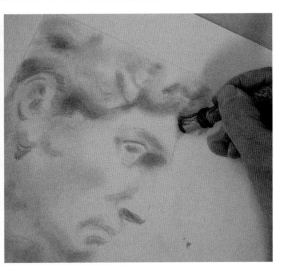

2 All areas that require graphite are hatched in at an angle and blended to a smooth finish using a paper stump. There are very few sharp highlights in the reference, so try to keep all edges of tone soft at this stage, retaining the white of the paper for the most high-key value.

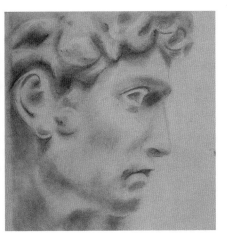

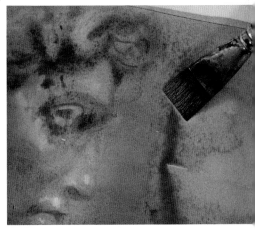

3 After the initial hatch and blend, pause to assess the work and make any corrections, because there is no going back once the ink is applied: it cannot be removed, and will also "fix" the pencil marks in position.

4 Mix a middle tone of ink, using an approximate ratio of 50:50 ink to water. With a flat brush quickly fill in all areas that require this tone. Working quickly, because the ink dries fast, use a synthetic brush to carefully ink around the profile, leaving the edge as white paper.

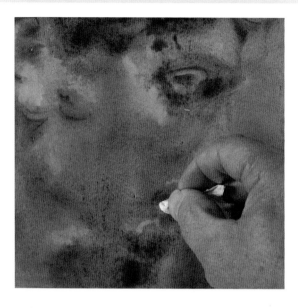

5 Reinforce the first ink washes with a second application of the same ink mixture, allow to dry, and add a third if necessary. Before the ink has dried, use tissue to dab away highlights on the cheek areas, hair, and lower lip.

6 Now start to overdraw the ink with soft pencil hatching strokes, following the surface directions to help describe the form. Softly blend some of these marks where necessary, then, using a 4B pencil, add the darkest darks.

Ancient Warrior

7 The finished picture remains faithful to the reference. The soft, almost pink hue of the diluted sepia ink suggests a flesh-like quality, yet although the head has received detailed modeling with both pencil and ink, it still retains its character and integrity as a piece of sculpture.

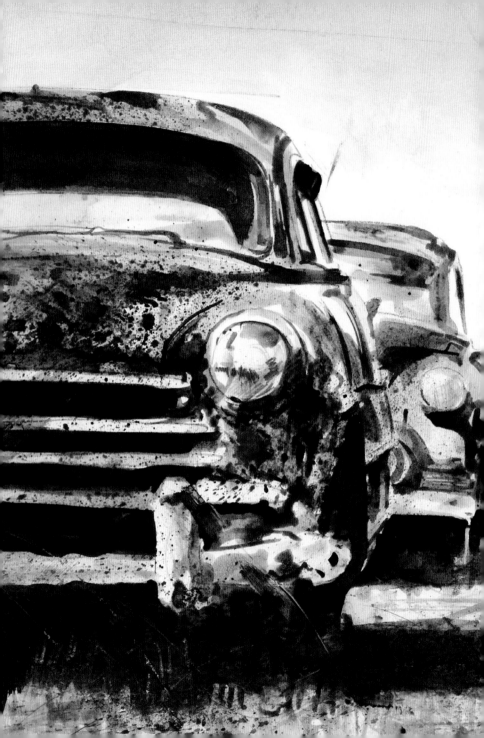

Chapter 5

Gallery

Lighting

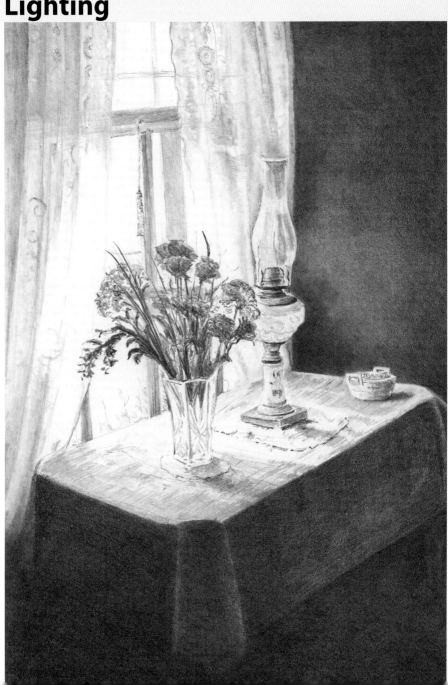

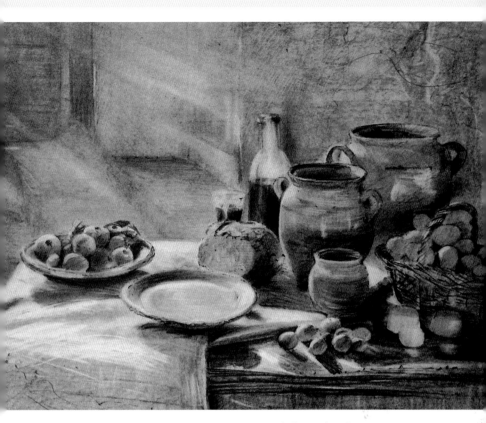

◄ **Queen Anne Lace**
Diane Wright
Graphite on smooth watercolor paper
The kind of lighting you choose has an enormous effect on how the subject is perceived. Still lifes lit from behind by natural light are always popular, because this form of lighting produces strong tonal contrasts as well as slightly reducing the detail on the objects themselves. Notice how cleverly the artist has set up a link between the wildflowers and the curtains by lightly suggesting a lacy pattern at the top.

▲ **Expecting Company**
David Poxon
Graphite pencils HB, 2B, 4B, 6B
on drawing paper
In this lovely drawing, the beams of light coming in from top left form a vital part of the composition, as the diagonals lead the eye toward the groups of objects. The artist achieves his effects by building up successive layers of blended pencil marks, and the beams of light as well as many of the highlights have been lifted out with a plastic eraser. For an evenly lit approach to this subject, see page 143.

Kitchen subjects

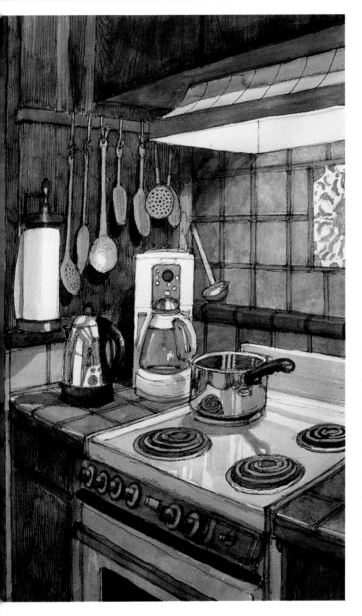

◀ **Kitchen Still Life 1**
David Arbus
Pen, ink, and wash
*Kitchens, and the range of
implements used in them,
provide a marvelous source
of still-life material, with
a fascinating variety of
different shapes and
textures. In this drawing,
the artist has placed the
main emphasis on the
shapes and the tonal
pattern, with the large
and smaller white shapes
carefully balanced, and
the curves and straight
lines repeated all over the
picture area.*

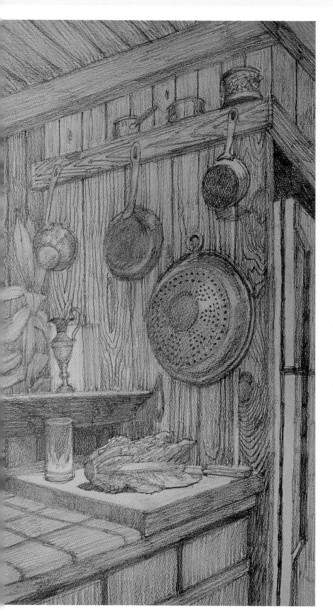

◄ **Kitchen Still Life 2**
David Arbus
Pencil on drawing paper
In this drawing by the same artist, the range of tones is relatively small, with just a few touches of dark on the right giving stability to the image. The contrast between the cylindrical shapes, the hard-edged verticals and horizontals, and the free form of the cabbage make this a drawing that is full of interest. The textures of the wood have been observed and drawn very carefully to provide a lively backdrop for the large colander, which is the focal point of the picture.

▼ *Apple Pie*

Diane Wright

Graphite on smooth watercolor paper

Fruit and vegetables are a commonplace of still-life work, but cooked food is a less usual subject—perhaps only because people of today cook less often that in the past. The pie and its ingredients, plus the rolling pin used for the pastry, make a lovely group, and have been carefully arranged to form a satisfying composition. The textures are skillfully described, with small areas of light shading for the crumbly pastry, long diagonal lines for the rolling pin, and curving directional strokes for the apples. Multi-directional crosshatching has been used to bring interest into the immediate foreground.

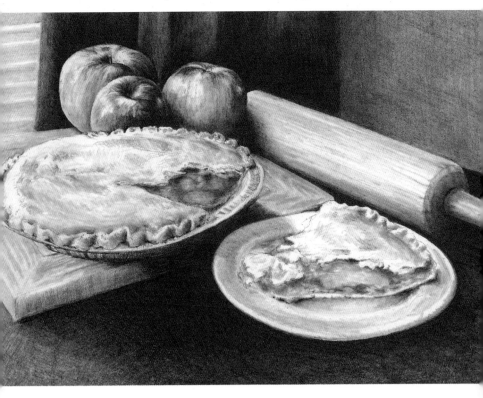

▶ **Morning Coffee**
Diane Wright
Graphite on smooth
watercolor paper
*This drawing derives its
main impact from the way
the three large shapes are
arranged to form a rough
triangle—artists often refer
to this compositional
device as "the hidden
triangle." The balance of
large and small shapes is
also very important, with
the handles of the coffee
grinder and milk churn
making a lively pattern and
emphasizing the solidity of
the objects. The artist has
arranged the coffee beans
with great care, so the eye
follows them in from the
right side of the picture.*

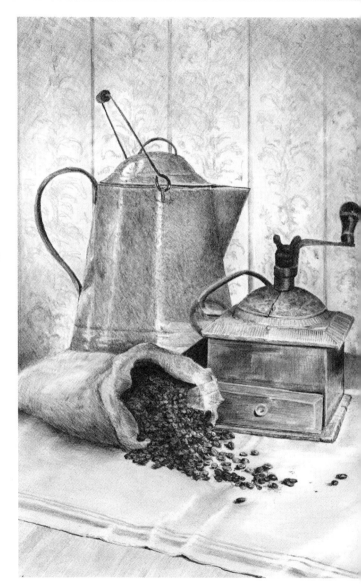

Treasured objects

▼ **Walking Boots**
John Glover
Pencil on smooth drawing paper
*Artists frequently draw and paint objects or items of clothing that mean
something to them, and what more evocative subject for an artist-walker than
a pair of boots. It is hard to look at them without remembering many shared
experiences, some perhaps happier than others. Apart from the associations,
boots are a rewarding subject to draw, but great care must be taken over the
placing of both the highlights and the laces, which together describe the forms.*

▲ **Guitar**
Tania Field
Charcoal on smooth lining paper
Using a long object like this as a still-life subject can pose a compositional problem—what to do with the spaces around it. The artist has solved this by bringing in the rabbit jelly mold, flower, and bottle as balances, and by setting the guitar on pieces of overlapping white paper, which provide both tonal contrasts and additional interest. The diagonally placed guitar leads the eye in from the foreground toward the solid body with its elegant curves.

Everyday subjects

▼ Keys
Joan Bray
Graphite pencil on toned drawing paper
Our lives are so surrounded by objects with practical uses that we seldom think of them as subjects for a drawing. Look again, however, and you may see possibilities in all sorts of things, such as kitchen implements and garden tools, although the subject of the drawing is less important than how you treat it. Here the artist has made a simple but highly sophisticated composition based on opposing diagonals. Although there are large areas of empty space in the drawing, it is far from dull, as the eye is drawn to the varied shape of the overlapping keys. Notice that the artist has only suggested the writing on the wallet in order not to draw too much attention to this area.

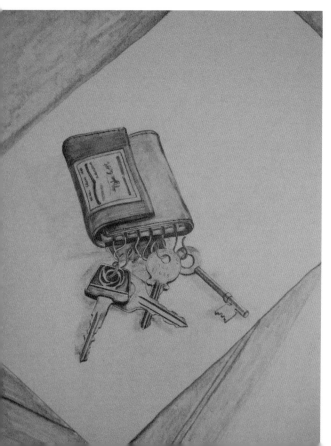

▶ Inks and Pots
Ron Law
Various grades of graphite pencil on drawing paper
Artists never need be stuck for a subject, because the studio is full of them, and there are few who have not made studies of their tools of the trade at some time. The artist has arranged the objects with care so that the two paint tubes on the right balance the central group, and has used a light source from the left that produces both highlights and cast shadows, the latter playing an important role in the composition.

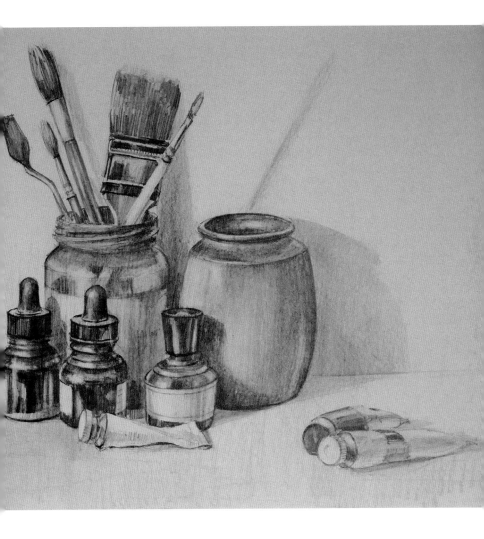

Outdoor still life

Mitchellville Barn
Diane Wright
Pencil on smooth watercolor paper
This drawing might seem to fit better into the category of landscape than that of still life, but categories overlap, and in fact the only things that are not actually still are the tiny birds. As well as paying close attention to the structure and the various textures, which have been built up very skillfully with different grades of pencil, the artist has conveyed a lovely sense of atmosphere by setting the ruined barn and fence against a wide expanse of sky.

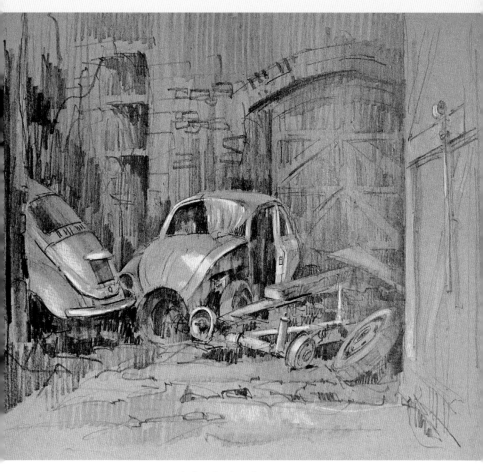

▲ Beetles in a Barn
Ron Law
Various grades of graphite pencil on toned paper
This drawing has a strong narrative element; we sense a story behind the abandoned cars and the farm machinery. The artist has used blending techniques to achieve the smooth metallic texture of the car bodies, adding the highlights with white chalk. In contrast, the surroundings have been drawn with firm, downward hatching lines using different grades of pencil, and the foreground is only sketchily suggested so that it does not claim too much attention.

Multiple objects

▼ *Studio Still Life*
David Arbus
Ink and wash
When setting up a large still-life group, it is important to consider the spacing between objects and how some can be overlapped without obscuring the forms. In this carefully composed group, the three large central objects overlap, while the small bowl just touches the edges of the front plant pot and the watering can. The smaller bell-shaped vessel occupies its own space, as does the glass, and the drawing implements are arranged so that they lead the eye into the picture. Notice how the artist has created a relationship between the foliage and the two plant pots by using similar patterns in both areas.

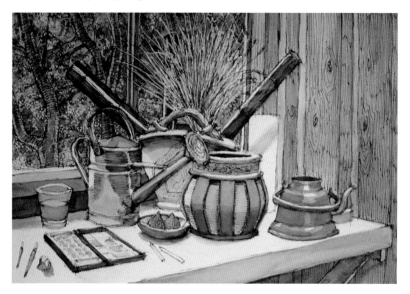

▶ A Frugal Lunch
Myrtle Pizzey
Graphite pencil
For this artist, the initial line drawing, made before tone is added, is of supreme importance, and she ensures that the relationship between objects is correct by drawing a grid and measuring the distance between objects. This accurate drawing allows her to draw boldly and freely thereafter. She likes to exploit pattern in her work, and in this drawing she has given the background considerable importance, deliberately sacrificing the sense of recession in order to create a strong overall rhythm. For another interpretation of this subject, see page 131.

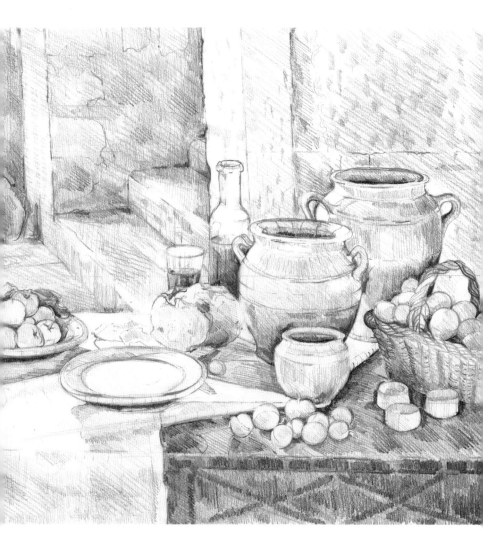

Single objects

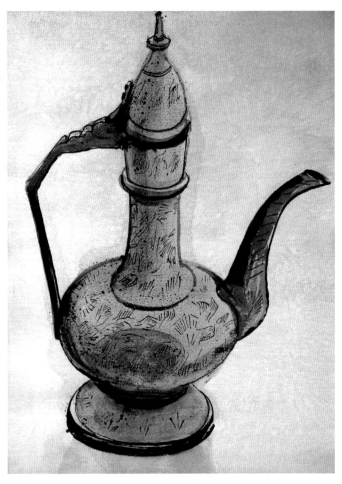

▲ **Brass Pot**
John Jebb
Pen and ink washes
*When drawing a single object it is important to consider how to place
it on the paper. Here the vessel has been placed slightly off center, with equal spaces at
right and left between the edges of the paper and the ends of the spout and handle.
If these had been butted up to the paper edges, the vessel would have looked
constrained and uncomfortable. The drawing has been given extra interest by the close
attention to texture, with tiny pen marks describing the raised areas and declivities.*

Plants and flowers

▶ **Rose and Wild Vetch**
Martin J Allen
Graphite pencils 4H, HB, 2B
The two plant forms have been
very cleverly arranged for this lovely
drawing. Because the rose stem
makes a strong, uncompromising
vertical, the drawing would have
looked dull without the curves
brought in by the vetch curling
around the stem and over the top
of the bloom. The drawing has
been built up slowly in layers,
working from light to dark until
the full depth of tone is achieved.

▼ *Pot Plant*

Joan Bray

Graphite pencil

This composition has a lovely sense of movement, with the stalk and leaves trailing over the front edge of the table. It is always best to "break" a strong horizontal in the foreground of a picture, otherwise it acts as a block, but here the curve leads the eye straight to the ellipse of the bowl and the strong shape of the pot.

▶ *Peony*

Joan Barnes

Graphite pencil

The forms of this flower are so intricate that it encourages a close-up approach. The artist has treated each area of tone as a separate shape, using outlines around the lightest tones to give additional emphasis. Soft pencil has been shaded heavily around the petals at bottom and right to contrast negative and positive shapes.

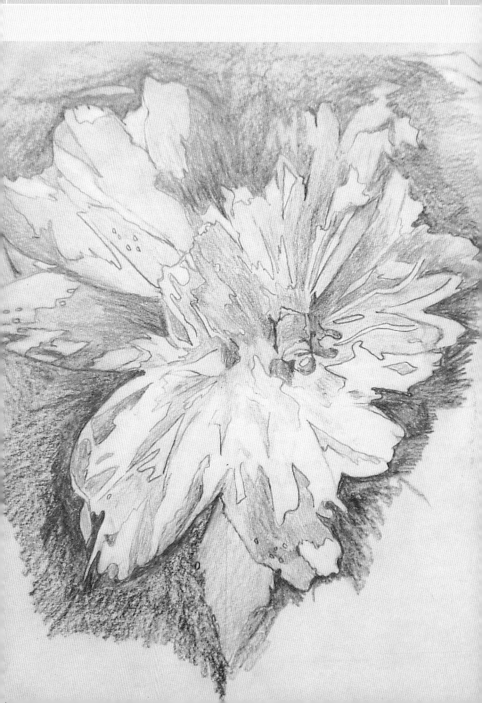

▼ Daisy, Daisy

Joan Barnes
Graphite pencil

All the flowers in the daisy family make attractive floral drawing subjects, and are easier than some because they are based on simple circles and ellipses. Notice how the artist has stressed the way the petals push outward from the center by using directional pencil shading behind the front flower, creating a dark halo that echoes the shape of the flower.

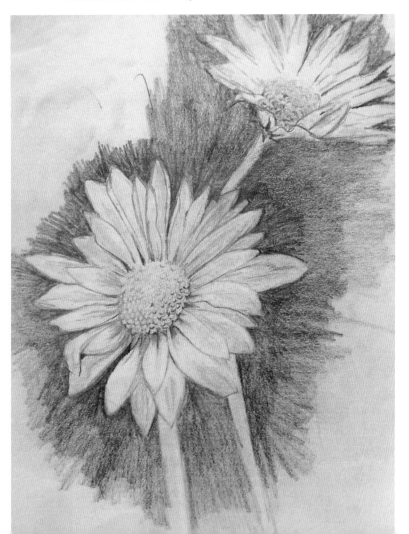

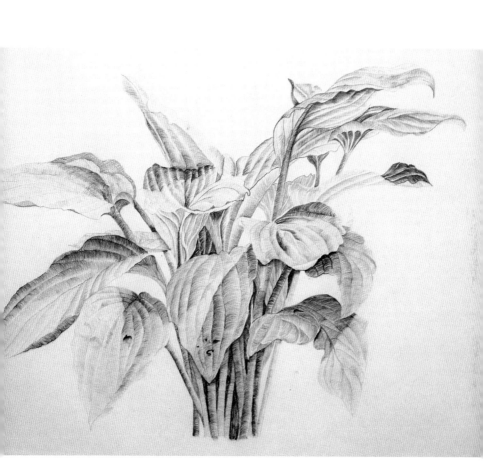

▼ *Copy of Hosta*
Joan Bray
Graphite pencil
In this drawing, the artist has created an unusual effect by omitting the pot in which the plant stands, so that it appears almost to float in space. This sense of movement is reinforced by the contrast between the massed stems and the curving, wing-like leaves.

Pattern and texture

▼ **Chocolates**
Katriona Chapman
Graphite pencil 6B
In this exciting drawing, the artist has contrasted the simple shapes and smooth texture of the chocolates with the intricate pattern made by the crumpled foil. She has used blending methods for the chocolates, but has treated the foil as a series of hard-edged shapes, working carefully around the many small highlights.

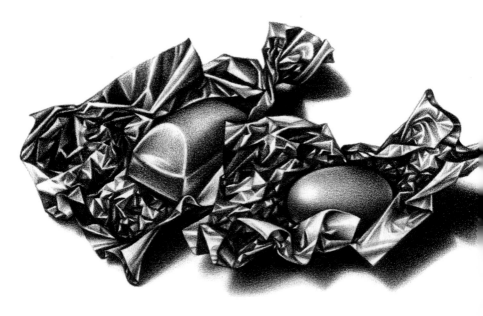

▲ *Leaf*

Katriona Chapman
Graphite pencil 3B
*In this drawing, the curling edges of the leaf have been
deliberately exaggerated to create an exciting pattern of large
and small curves. Notice how the artist has used cast shadows
to bring in additional shapes, and also to create a dark area
that balances the deep-toned shadows on the leaf itself.*

Surrealistic effects

▲ *Skull*

Joan Bray

Charcoal, ink, and white chalk on toned paper

We have to look twice at this powerful drawing to decide what it depicts. In spite of the title there is considerable visual ambiguity; many of the forms are soft and flower-like rather than hard and bony, and the overall shape suggests an exotic flower. The artist has used her knowledge of both plant forms and human anatomy to create a highly surrealistic effect.

▶ **Objects on a Table**

Sarah Adams

Graphite pencil

By placing the sauce boat and cup on their sides, the artist has created an uneasy impression, almost as though the elements of the composition have been disturbed by some outside force, perhaps an unfriendly one. This feeling is reinforced by the way the objects have been placed, with the gravy boat seeming about to topple off the table, and by the highly realistic, almost photographic drawing technique.

Interiors

▼ Old Brewhouse Corner
Bridget Dowty
Charcoal
A subject like this could look dull if it were not for the strong tonal contrasts and the use of diagonals. The verticals formed by the sunlit window give stability to the composition, while the diagonals lead the eye toward the array of shapes that form the center of interest.

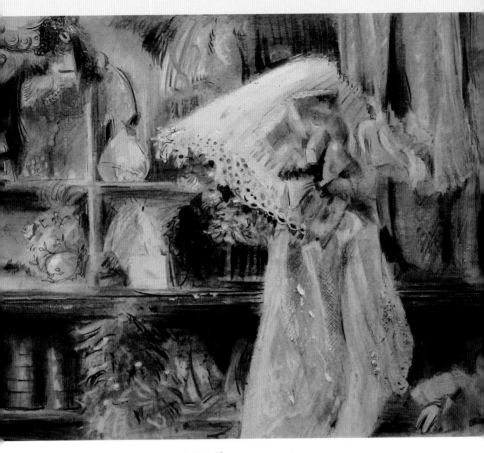

▲ *Hat Shop*
David Poxon
Graphite pencils HB, B, 2B, 4B, 6B
Opportunities for drawing interiors and other still-life subjects may present themselves quite accidentally. The artist was forced to take shelter from the rain in a Victorian hat shop, became fascinated by the skill of the hat makers, and spent the rest of the day drawing in the shop. The lavish display of fabrics gave him a wonderful opportunity to explore shapes and textures, although none of the objects, except for the swathe of lacy fabric, are described in detail.

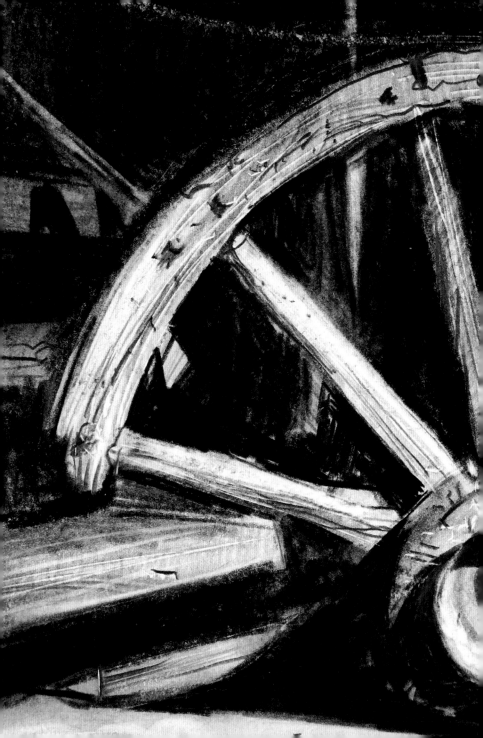

Chapter 6

Subjects

Rendering texture

Wood grain
The key to realistic rendering of this type of natural material is to closely follow the direction of the grain, paying attention to any special features. In the close-up drawing above, notice how the grain direction lines swirl around the knot in the wood.

Old door

Subjects like this are highly suggestive, giving a
sense of history —who knows who might have
passed through this door and for what purpose. In
terms of treatment the texture is vital, so try to get a
sense of this with impressing methods, trying
different types of incising tools in key areas.

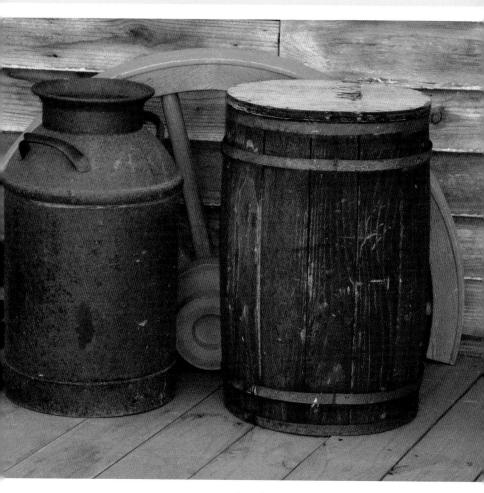

Barrels

This is an overall medium-toned subject with little in the way of contrast. Diluted sepia or black ink could work well with this subject, but you might need some line drawing to introduce definition and contrast.

Picnic hamper

There are lovely textures to play with here. Study the weaves in the basket carefully, and use the faint shadow lines to help show form.

Bread basket

With a subject such as this, you will need to implement a combination of techniques if you are to render the textures accurately. Use your multiple blending techniques for the basket, paying particular attention to the weave. The bread can be impressed with an incisor, and then hatched and blended over. Pick out highlights using a plastic eraser.

Drawing shadows

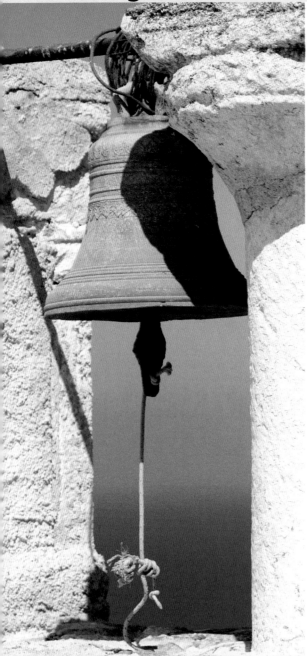

Bell

This bell image is an excellent vehicle for practicing your cast-shadow techniques, but always remember that the shadows are not merely dark gray or black shapes; they have subtle gradations of tone just like the objects that cast the shadows.

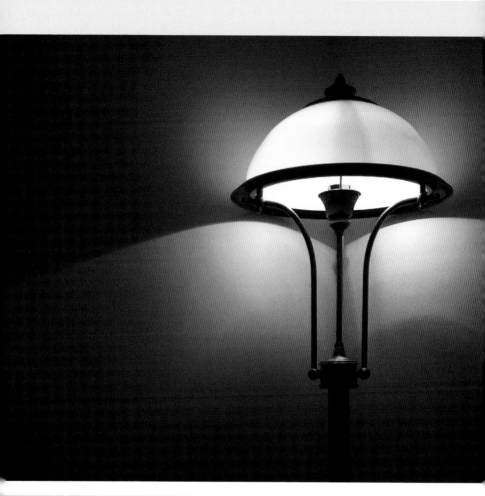

Lamp

This interior lit lamp casts several types of shadow. There are hard edges to the initial light source, but looking closely you will see these fade into soft edges. When recreating this image on paper, work the dark background through the whole tonal register, starting with extreme darks and gently gradating the blend as you get closer to the light.

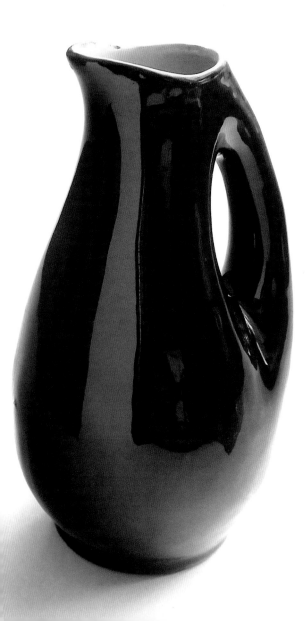

Jug

This jug is a more traditional still-life object than many in this book, but such objects provide excellent drawing practice. Look carefully at the tonal gradation, because the contrasting tones of the decoration make the shadows that describe the form difficult to read. If the background is left as white paper, the entire rendering must take place on the surface of the jug.

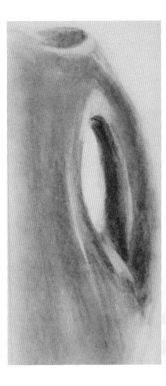

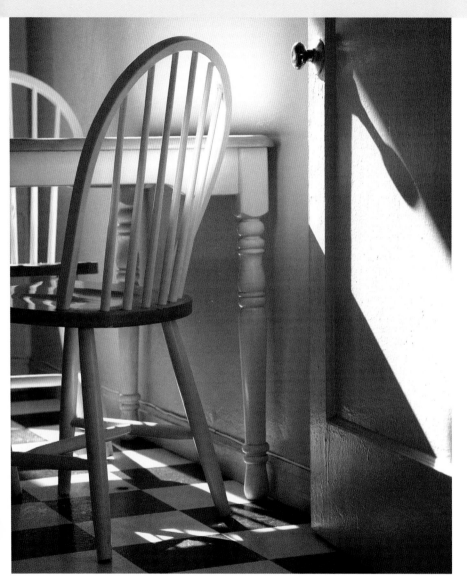

Chair and table

The simplicity of this subject hides tricky but challenging aspects for the artist; firstly how to see and translate the tones of what the artist knows to be white in reality but that look to be a fairly limited range of mid-grays in the picture; and secondly how to capture the detail within the shadow areas with the limited range of tones. Using a monochromatic scale held against the image to analyze the tones will help.

Negative shapes

Frosty leaf

A high-key, delicate subject like this requires a subtle approach. Don't commit to drawing specific darks or outlines first. A better method would be to block in the background with a soft mid-tone, leaving all the edges of the leaf as soft suggestions. The sketch shows the first stage of the drawing process, with the leaf left as a negative shape.

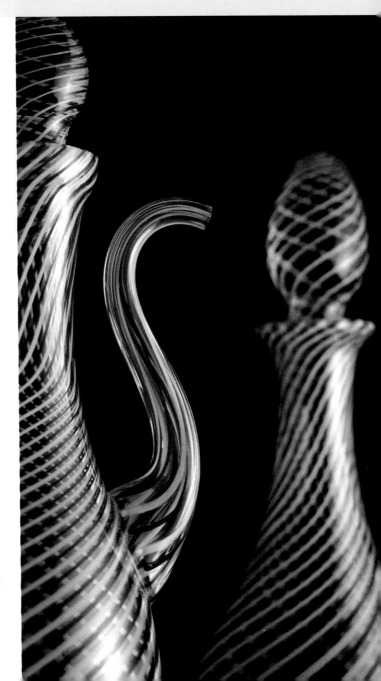

Glassware
These objects are set against a very dark background. One approach would be to draw and shade the dark area first, leaving the objects as negative shapes, then work on rendering the objects themselves.

Light and reflection

Gramophone
This is a wonderfully nostalgic subject. Concentrate on the old record player and its soft reflective qualities, but also note that the background is suggested with no hard outlines. This helps place the object in the foreground.

Windows

Glass windows act much like mirrors, except that the tonal range of the reflections tends to be much deeper than the object reflected. Don't be afraid to leave areas almost tone free, or perhaps suggesting scudding cloud shapes in the window. Your darkest tones should be reserved for the broken section.

Chair

Some subjects appear at first to have little to offer, but look again. There are positive reflections on the chair seat, which if drawn carefully will give a sense of atmosphere, as well as explaining the forms. Always blend reflections in a vertical direction.

Rowing boat
*In still water, reflections are long and vertical,
but in choppy water they spread out sideways in
a more random manner, so use a combination
of horizontal, vertical, and diagonal strokes.*

Pans
Shiny surfaces are highly reflective, which can confuse the issue. You could treat this kind of subject as a pattern of different-toned verticals or simplify it by looking for key highlights, as in the rims of the pans and textured foreground.

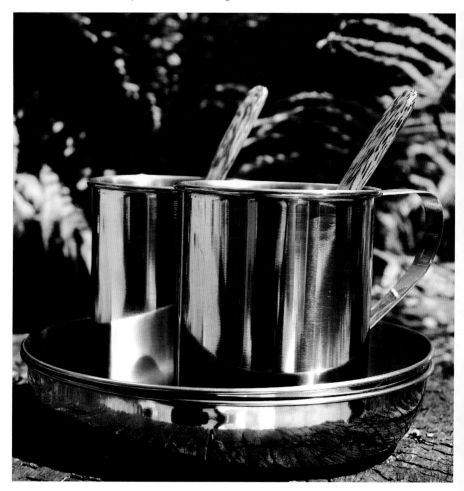

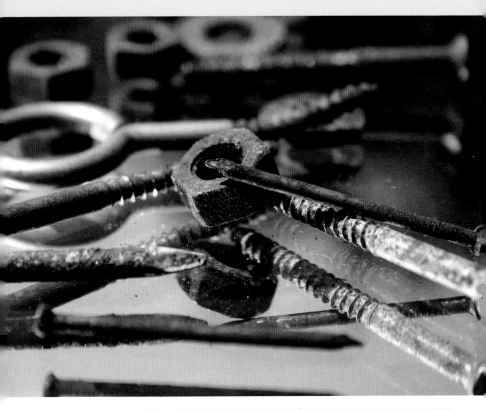

Nails

A simple composition of scattered nails, screws, and bolts resting on a reflective glass surface requires careful observation if you are to recreate this accurately. Retain the sharp textures of the rust and screw edges and contrast these with the soft blurred shapes in the background.

Drawing ellipses

Center line

Center line

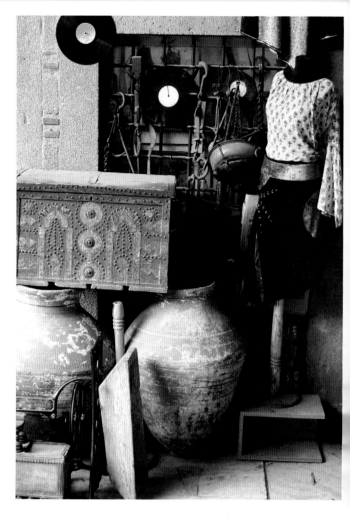

Junk shop

You could tackle the whole subject, or pick out individual items for special attention, rearranging the order if necessary. As in many still-life subjects, you will need to address the problem of ellipses. A good way to start is to make a faint rectangular outline first. Draw two diagonal lines from corner to corner—this will locate your center line and center point. Mark off an equal distance in from both sides. In this smaller box, you will draw the ellipse. Now use this framework to help locate your ellipse and sides of the jug.

Old store

A rich, almost medieval
monochrome image of
round metal containers
at different angles
gives ample practice of
observing and drawing
ellipses. Make sure you
get the highlights on
the correct point of the
ellipse—the shadow
areas are a bit more
forgiving because
they blur into the
background. A
good trick is to check
your drawing in a
mirror—any
imperfections will
be more obvious
because your eye will
not be accustomed
to the shapes.

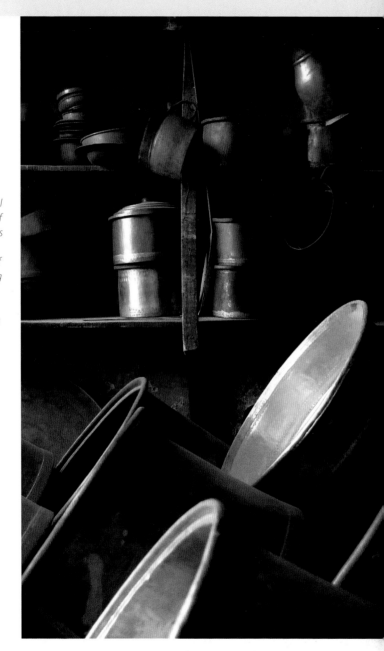

Rings

The central ring can be your focal point, and you might find it easier to get this element right first. Try fading and merging the left-hand side of the ring into the darkness so that the actual edge isn't so clearly defined. Pick out your highlights carefully to give the viewer the landmarks necessary to fill in the rest of the "form" in their mind's eye.

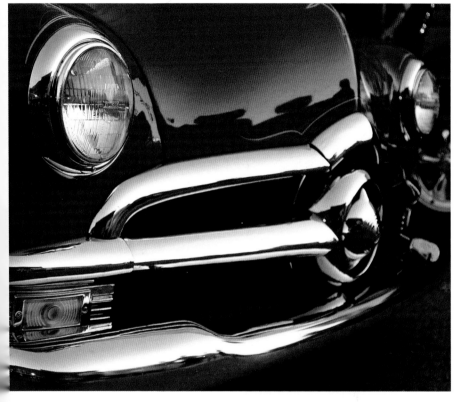

Car

The car headlight gives you another chance to practice ellipses. To achieve the shiny highlights leave white paper, and a few well-placed shadows blended in the right direction are all that's necessary to indicate the curved forms of the car body.

Distortion

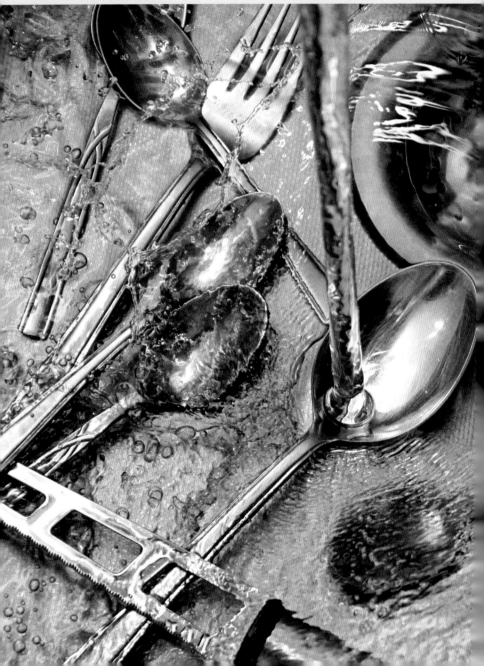

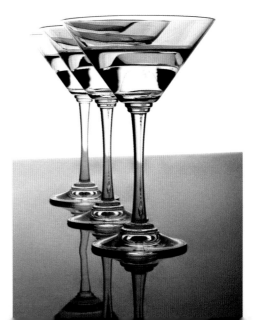

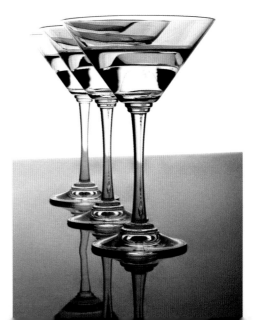

▼ Martini glasses

Glass can also be distortive. The overlapping transparent edges of the Martini glasses, and the clear Martini they contain, creates an altogether distorted image for the artist to explore.

◀ Washing-up bowl

Water distorts edges, and some disappear altogether. Start with the shapes and edges you can see clearly, but leave some unresolved to give a sense of the drifting water.

Making compositional choices

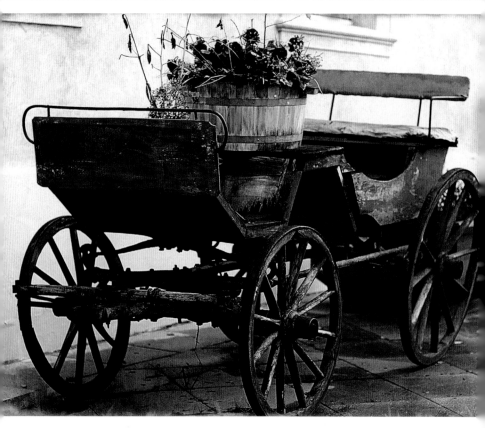

Wagon

There are some compositional choices to make with this scene. Decide what you want the focal point of your picture to be and aim to position that detail over an intersecting third on your paper. Fit the rest of the subject accordingly. Make your focus the area of greatest contrast by reserving your darkest dark and lightest light for this section.

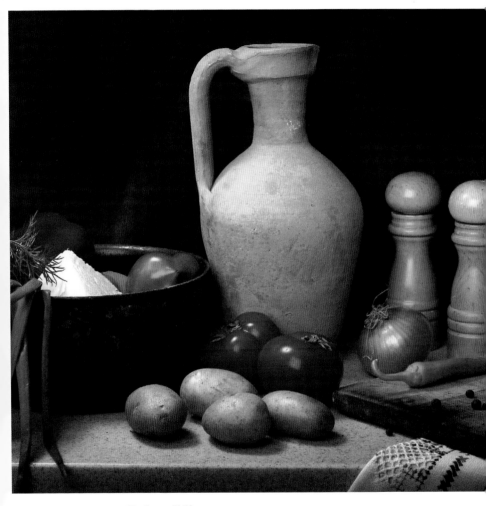

Kitchen still life

This is a traditional still life that most people could replicate with a few objects from their own kitchens. Note that this composition is deliberately posed rather than found, so be aware of the possibilities that changes in lighting might bring to the subject.

Place setting

The napkin is important to lead your eye into the picture, but it will test your blending skills, because there are very subtle tonal shifts with no real hard edges to lock onto. Leave plenty of clean white paper as highlights on the glass, and for extreme whites in the material.

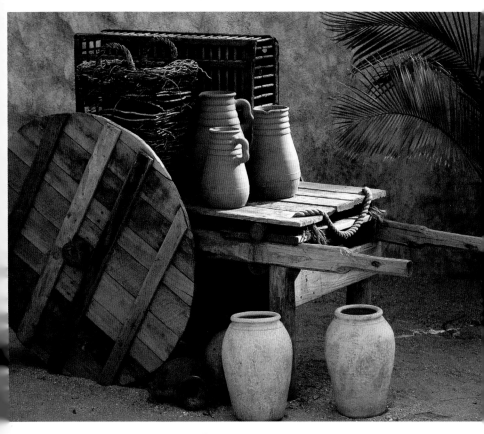

Rustic cart

This rustic subject gives the appearance of being especially arranged for the still-life artist. The tabletop jugs are the center of attention, and all other objects appear to point their way, including the cart handles and ferns. Slightly distracting are the pots on the ground, you might like to leave these out, or move them to the right of the main subject. This would balance the composition more effectively.

Capturing form

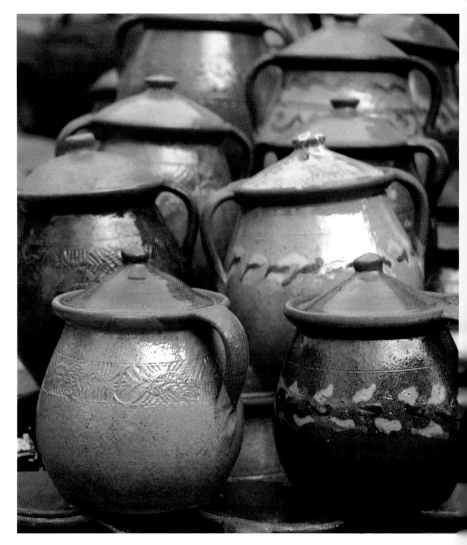

Chinese jugs
*There are some lovely shapes here in this balanced, harmonic composition.
To give a sense of recession, notice how the edges become softer as the pots
recede into the background. What is known as aerial perspective makes tonal
changes less dramatic and edges softer as objects recede.*

Pinecones

This is a complicated subject. Think of the cones as spirals, and add details to a faint guideline. Use the principles of counterchange to help differentiate the forms, some cone edges are light to mid-toned, others are dark.

Index

All materials and techniques are illustrated
Page numbers in *italics* refer to named drawings or photographs

Credits

Quarto would like to thank and acknowledge the following for supplying the illustrations reproduced in this book:

The Wellington Museum, London, UK/ The Bridgeman Art Library: **8**
Museo Archeologico Nazionale, Naples, Italy/The Bridgeman Art Library: **9**
Bettmann/CORBIS: **10**
Burstein Collection/CORBIS: **11**
Ali Meyer/CORBIS: **12**
Louvre, Paris, France/Giraudon/The Bridgeman Art Library: **13**
Igor Smichkov/Shutterstock: **158**
Alexander Gehre/Shutterstock: **160**
Lindsay Dean/Shutterstock: **161**
Lisa F. Young/Shutterstock.: **162**
Magdalena Kucova/Shutterstock: **163**
mdd/Shutterstock: **164**
Jan Matoška/Shutterstock: **165**
Denis Selivanov/Shutterstock: **166**
iofoto/Shutterstock: **167**
Hamiza Bakirci/Shutterstock: **168**
Ahmet Cuneyt Selcuk/Shutterstock: **169**
N Joy Neish/Shutterstock: **170**
Paul Picone/Shutterstock: **171**
Susan Fox/Shutterstock: **172**
Willem Dijkstra/Shutterstock: **173**
Galyna Andrushko/Shutterstock: **174**
Patricia Hofmeester/Shutterstock: **175**
Emin Ozkan/Shutterstock: **176**
Andriy Rovenko/Shutterstock: **178**
Vilmos Varga/Shutterstock: **179**
Perov Stanislav/Shutterstock: **180**
Gilmanshin/Shutterstock: **181**
Andrey Kozachenko/Shutterstock: **182**
Shyya/Shutterstock: **183**
Glen Jones/Shutterstock: **184**
Glenda M. Powers/Shutterstock: **185**
Dimitrije Paunovic/Shutterstock: **186**
Marek Szumlas/Shutterstock: **187**

Quarto would also like to thank the following artists who are acknowledged beside their work:

Sarah Adams

Martin J Allen (www.martinjallen.com)

David Arbus (www. davidarbusfineart.com)

Joan Barnes (www.joanbarnes-wc.com)

Joan Bray

Katriona Chapman (www.iris-illustration.co.uk)

Bridget Dowty (www.bridgetdowty.co.uk)

Tania Field

John Glover (www.johngloverportraits.co.uk)

John Jebb (www.johnjebb.com)

Ron Law

Myrtle H. M. Pizzey S.G.F.A

David Poxon (www.davidpoxon.co.uk)

Diane Wright (www.dianewrightfineart.com)

All other illustrations and photographs are the copyright of Quarto Inc. While every effort has been made to credit contributors, Quarto would like to apologize should there have been any omissions or errors—and would be pleased to make the appropriate correction for future editions of the book.